OVERCOMING ORDINARY OBSTACLES

Boldly Claiming the Facets of an Extraordinary Life

NESHA PAI

SPARK Publications
Charlotte, North Carolina

Overcoming Ordinary Obstacles:
Boldly Claiming the Facets of an Extraordinary Life
Nesha Pai

Designed, produced, and published by SPARK Publications, SPARKpublications.com
Charlotte, North Carolina

Printed in the United States of America.
Softcover, December 2019, ISBN: 978-1-943070-74-9
E-book, December 2019, ISBN: 978-1-943070-75-6
Library of Congress Control Number: 2019917114

DEDICATION

To my son, Rupen, to carry on
the legacy of your grandfather.
The world truly is your oyster.

To everyone mentioned in this book and
anyone else who helped shape my life to
become the best version of myself, I am
truly grateful our paths crossed.

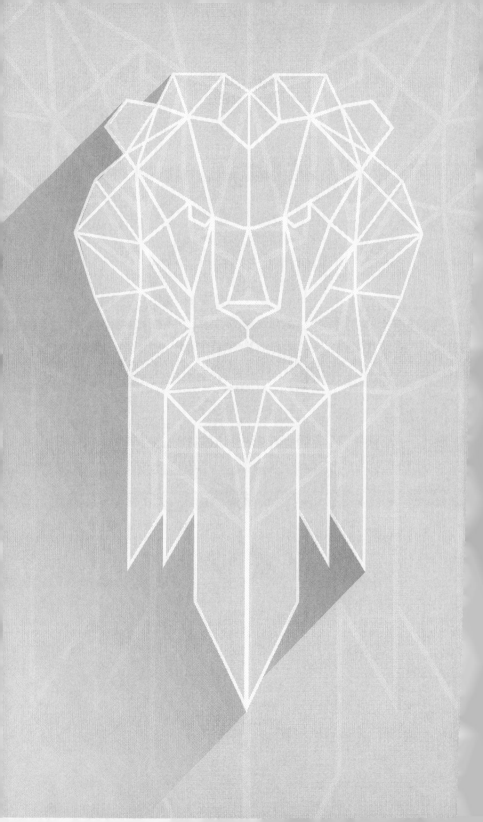

ACKNOWLEDGMENTS

I am aware of how privileged and blessed I have been throughout my years in being able to have a story to share. I have learned from everyone who has crossed my path. You cannot have good without bad, so I thank all the people who contributed to either of those categories in my life because everything led me toward God's purpose and calling.

I am deeply indebted to my parents. Though our journey together has not been easy, their love for me is unwavering, and their sacrifices for me to have a better life have not gone unnoticed. They continue to show me grace and have been my primary role models for how to live a Godly life, and their patience with me would make them saints. I wasn't the easiest kid to raise, being the rebel black sheep, so I give them all of the credit for working with me through everything they had to experience from my journey.

I thank Fabi Preslar and her team at SPARK Publications here in Charlotte, North Carolina, for helping me bring my story to life. Fabi took a chance on me, and when I came to her with my brain dump of merely 6,000 words and no knowledge of how to even go about writing a book, she and her genius staff brought my journey to life in a beautifully packaged book. I learned tremendously not

only how to write a book but also how to do so in a way that would honor my story and everyone in it. This has been a long-time dream, and I cannot believe that it has finally come to fruition. Through this process, I have healed parts of myself and been able to see my parents and my life through a more compassionate lens.

I thank Leonard Wheeler and Sara McMann, for their agreement to read my book and provide such beautiful testimonials. I am blessed to know such incredible human beings who are not only accomplished athletes, but also really good human beings trying to change the world in their own ways.

I am grateful to my Pai CPA team and clients for supporting my leadership and following me on this journey.

I am thankful for Cheale Villa and her company, Visual Caffeine, for creating the brand and the vision of the lion. The lion represents spirituality in both cultures I represent, and it symbolizes courage and conquering.

I am grateful to my inner circle; you know who you are. These people have been there throughout my journey, some at different times for different purposes. But each person has lifted my spirits or lent a helping hand or ear.

Finally, I thank my son, Rupen. He is the reason I am here, my purpose in this life. He has not only given me the gift of motherhood but also taught me how to expand my own heart and know how to give unconditional love, even when I didn't love myself in that way. His grace, strength, and dignity are unparalleled. His intelligence surpassed mine at a very young age, and his maturity is exemplary. He is the basis of every decision I make in my life.

TABLE OF CONTENTS

Introduction .. 1

CHAPTER 1
Emigrating to the Land of the Free 7

CHAPTER 2
Searching for Identity .. 19

CHAPTER 3
Going with Plan B .. 39

CHAPTER 4
Letting Go of Expectations .. 53

CHAPTER 5
Taking the Leap .. 69

CHAPTER 6
Making Your Own Lane ... 85

CHAPTER 7
Manifesting Your Dreams .. 97

CHAPTER 8
Removing the Barriers to Love 107

CHAPTER 9
Rejecting Dogma and Finding God 121

About the Author .. 142

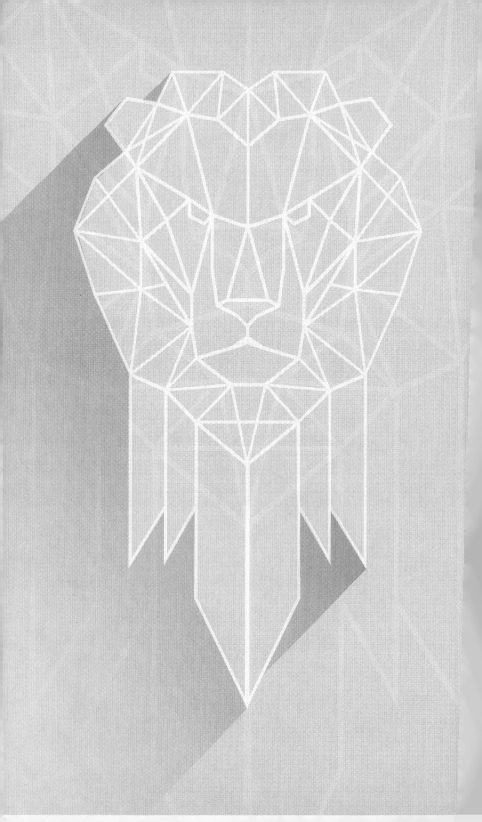

INTRODUCTION

We all face obstacles in our lives, and as soon as we overcome one, another one usually pops up. It seems that nothing ever goes as we planned. And some experiences are so painful that it's hard to find a silver lining. But I've finally learned to see beauty and unexpected blessings in those hard times too.

And because of that, I've become someone whom others come to seeking advice. I consider that to be the utmost compliment, and I'm humbled whenever I can be a rock for someone in their time of need. It's not that I'm anyone special or that I've overcome more obstacles than the average person. I'm just an honest, open, God-loving woman who has always chosen what is right over what is easy.

I wrote this book as a way to share my journey in the hope of helping others. While a lot of things in my life have not gone the way I envisioned, everything has worked together for the greater good in my life. I have taken the lessons I've learned during difficult times and used them for my next challenge. It took a lot of humility and fortitude to stay on course. My path has not been easy, but I believed in myself amidst all the struggles.

I've shared reflection questions at the end of each chapter to help you work through some of the issues you might be facing. I hope to motivate you and help you navigate the troubled waters of your own life. We all must learn how to cope with the inevitable—the stuff that derails our goals and dreams. That is, if we want a joyful, healthy, fulfilling life. The first step in your own journey, which is nonnegotiable, is the absolute belief in yourself.

My life has been blessed because two incredibly brave Indian immigrants—my parents—came to this country to give me a better life. I believed at a very young age that the world was my oyster and that I was destined to be great. I wasn't being cocky; I just somehow knew that God planted something deep inside of me to share with the world. I knew that I wanted to leave a legacy that I could be proud of. I didn't want to live an average life flying under the radar or scratching at the surface of greatness.

My first thank you goes to my amazing God, who has opened my heart in ways I never imagined. The love that now flows within me and from me is something I wish I'd experienced earlier in my life, but to discover this kind of joy in midlife is still a blessing and a gift. God gets all the glory.

While our journey together hasn't been perfect, I'd also like to recognize my parents, who are the very foundation of who I am. I humbly thank my father for taking a chance on coming to this great country to follow his dreams. He bravely left his family and all he knew behind. My father gave me the chance to create every opportunity I have ever

had. He had the intestinal fortitude and vision to create a new life for future generations. And he gave me the gift of being a fighter and a boundary pusher. I wasn't made to conform. I was made to pave the way, like he did. My dad is my hero and my role model. My dad never gave up; he just worked harder.

I graciously thank my mother for being selfless as she put aside her dreams in order to raise my siblings and me. Still a child herself, she married a man she hardly knew and came to a foreign country halfway across the world to start a new life. My mother showed me what it is to sacrifice and keep a family together. While she and I have very different personalities, my mother's will to adapt and survive provided me with an example I carried through to my own life.

My son gave me the gift of motherhood, expanded my heart, and taught me unconditional, selfless love. We both went through some pretty rough times in the early days of his life, which set the tone for challenges to come. My son is my second hero. He overcame obstacles with grace and strength, and his example helped pull me through as well. His obstacles started the day he was born. He is carving out a special path for himself. I believe now, as I believed on the day he was created in my womb, that my son is destined for greatness.

This book is a labor of love, sharing my life's journey and the personal experiences that have provided valuable lessons. Our greatest achievements and successes cannot come without pain and struggle.

I was criticized by extended family and family "friends" for years, being labeled a rebel, a black sheep, and a boundary

pusher, but I've learned to embrace those labels because they represent my greatest assets. I am not here to simply exist or survive—I am here to thrive.

And you should be too. Overcoming obstacles is part of the process. And how you handle obstacles will be the determining factor between living a life full of joy and living a life of unhappiness and struggle. My hope is to inspire you to become the greatest version of yourself as you face your own trials. You aren't here to be average—you are here to be great.

EMIGRATING TO THE LAND OF THE FREE

"I knew from an early age that I did not want
to simply survive; I wanted to thrive by walking
into my purpose and becoming the
best version of myself."

As do many children of first-generation immigrants, I have learned that freedom is not free. The actions that my mom and dad took and the way they reacted to their experiences taught me that hard work and sacrifice are necessary elements to freedom. The work ethic they both displayed is deeply ingrained within me. But I didn't truly understand their journey and how it shaped their lives and therefore my life until very recently. That lack of understanding was a giant, invisible obstacle I kept bumping into even as I leapt over other obstacles to grow into the extraordinary life I am creating for myself. I eventually

discovered that I need to go back to the beginning, to my parents' beginning, to see the obstacle clearly.

My father grew up in an upper-middle-class family in the small coastal city of Mangalore in Karnataka, India. Upper middle class at that time did not compare to what it is today or what it means to us here in America. By Indian standards, owning a home and having house servants and drivers denoted that status. And since poverty was and still is so high in India, unskilled labor is plentiful and cheap, so having servants is more common there than here.

In any case, my dad, the second-oldest son of nine children, was the first of his siblings to have the desire to build a bigger life outside of the known. But he would have to leave the comforts of home to do it. After completing high school and college, he decided to go to America for higher studies and a better future for himself. His parents did not want him to leave home and go to a country halfway around the world. As the son of a successful businessman, he had a good life in India, but my father wanted more. He wanted to make it on his own, to be his own man. And America was a far-away land with endless possibilities.

At twenty-three years old, he embarked on his search for the American dream. On August 8, 1960, he became a crew cabin passenger on the SS *Steel Executive* cargo vessel, which set sail out of Mangalore. I imagine he felt as alone on that inhospitable cargo ship as Pi Patel did in the best-selling novel *Life of Pi*. He had the equivalent of $8 in his pocket. He endured sea sickness, pain, and loneliness during that

twenty-one-day journey to America, not to mention that he was a vegetarian on a ship that served only meat.

When he arrived in New York City, he knew no one. It takes my breath away to think about what he went through to come to this great land. I wonder if he knew exactly what he wanted his future to look like and how his dreams would manifest.

No one in my father's family understood why he would leave the comforts of his life and travel so far to further his education and start a new life on the other side of the world. In India, his family had household help, and he had drivers at his disposal; he would not have had to pay rent or secure a mortgage. Home ownership for a single nuclear family was rare at that time. It was customary for extended families to live together, with the oldest father being the patriarch. My father would have continued to live in the same house in which he was raised.

But my dad was a rebel and a visionary. In those days, coming to America was a huge deal, one that carried prestige. He came to America to pursue his master's degree and to have his own life, with his own family, in his own home.

Eventually, he made his way from New York to Lowell, Massachusetts, via a Greyhound bus. He was accepted to Lowell Technological Institute, where he excelled, receiving his master's degree in just three semesters. While in school, he found a part-time job in a shoe manufacturing facility to help pay for expenses. After graduation, my father worked for two years in a manufacturing facility in Maryland to gain practical experience.

My dad adapted well to this country and most likely reveled in his newly found freedom. Four years later, in December 1964, he went back to India to marry my mother and bring her back to the United States. At the time, they were the only ones in their families to have emigrated to the US.

My parents' marriage was arranged, as were most marriages among their upper caste (more on castes later). Arranged marriages were and still are a very common practice within the Indian culture and Hindu religion since the fourth century. It began as a way of uniting and maintaining upper-caste families. Marriage is considered a union of two families rather than two individuals; therefore, the parents pick their child's mate. They believe that they are more experienced and objective than their children and believe the proper mate will both protect the ancestral lineage and ensure that their child stays vigilant in their religious beliefs. The marriage signifies the woman leaving her nuclear family and becoming part of a new family, the husband's. The husband's family even gives the wife a new first name.

My father was twenty-eight years old when he married my mother, who was only eighteen. Their families had known each other for quite some time in the small coastal town where they all lived, but my parents had known each other for mere hours before their wedding. Ironically, the best schools in India are Catholic schools, so my mother was educated at St. Agnes School in Mangalore. She would pray with the Catholic nuns in school during prayer time but then go home to her Hindu way of life. Eighteen was considered the perfect age for women to get married because they were

not expected to go into higher education, but rather were ready to become wives and mothers.

Still a child, in my opinion, my mother had to leave her family and go halfway around the world. She barely spoke English and knew no one when she arrived in America. In the early years, my dad spent most of his hours at work, trying to prove himself and provide for his new wife. My mom spent most of her time alone and lonely, calling her own mother in India every day. How homesick she must have been. It took a full twenty-one days for her letters to reach her mother in India. In today's world of email and the Internet, that seems like an eternity.

My mother's new life was daunting in every respect. She experienced the cold and snow of mid-Atlantic winters. And she had to learn to do housework. Cleaning a bathroom for the first time was an eye-opening experience for her. Coming from an upper-middle-class Indian home where housemaids did all the cleaning, she likely wondered what she had gotten herself into. Adapting to American self-sufficiency was a challenge; she felt that the land of the free was not so appealing.

My mother learned how to drive a stick shift and obtained her driver's license at age nineteen. She and my father shared a car. My mother's first job was working as an accounting clerk at a big drug company, and she later worked for the town newspaper.

When she and my dad relocated to a small southern town in Tennessee in the early 1970s, life was even more challenging for my mom. It took her six years to become

pregnant with my twin brother and me. My brother and I were not the easiest of babies, and there were two of us. My mother had no family in this country to help her, and she managed us alone most of the time. But as we grew, she did more than just take good care of us; she began to create a new life for herself. She made friends and took vocational classes to learn how to sew and type, finding joy in cooking new recipes and substitute teaching at our school. She bought American clothes and traded her saris for pants. Watching my mother adapt to a small, white, Southern town was commendable because it appeared that she had no one who truly understood her or where she came from. That had to be the loneliest feeling in the world.

My beautiful mother always held on to her deep Indian values. Her values included placing family first, and being that she was now in a new family, she was very serious about obeying her husband, keeping her place as his wife, and being the nurturer of the family. Each morning she carefully applied her bindi (the dot that Hindu women wear in the middle of their foreheads to signify they are married) and prayed twice a day. She would make South Indian meals from scratch daily for my father. My favorite meal was idli (a savory rice cake made by steaming a batter consisting of fermented black lentils and rice). She would make the batter and move it to a cool, dark place in the corner of their bedroom to let it rise. I watched her miraculously create traditional meals with what she could find in local grocery stores where classic Indian culinary ingredients were scarce.

It was important for my mother to go back to India each summer to see her family. The journey was long, and she often made the trip with two young kids, and eventually three of us, in tow. We'd fly to JFK Airport and then on to Heathrow and then to Bombay and finally to Mangalore.

On one trip, we had to deplane on an emergency basis in Athens, Greece. My mother handled herself so gracefully when we were forced to sleep in a cold, dark hotel room for the night. For my mother, seeing her parents and extended family again was well worth the long, difficult journey to India.

My brother and I (and eventually our younger sister) were the cool "American cousins." My mother always enjoyed her time in India; every time we left, she would cry.

I wondered if she was truly happy being in America. Many times, she told me that she was "doing her duty" in her role as a wife and mother. As I entered my teenage years, she spent a lot of her time taking naps, so I always questioned if she was depressed during those years. Sadly, when her parents passed away, she could not be there. She received the news of her mother's death by a Western Union telegram in the '80s.

Dad, on the other hand, lived life to the fullest, and because he was in America, he made sure we took advantage of our freedom. He was the life of every party, always telling jokes and making everyone laugh. He took us on great road trips to experience places like Gatlinburg, Chicago, Orlando, and the Atlantic Coast beaches. Dad made sure we ate at Pizza Hut every weekend and celebrated important family occasions at fancy restaurants. He wanted to give us the kind of life that was nonexistent for him growing up. Even with

wealth, these options were not available in India, nor was the freedom to choose them, especially for women.

I commend and applaud my mother for her resilience. She did not have a college education and barely spoke English, yet she had the courage and tenacity to work in a clerical position for an American company. By comparison, there is no challenge I face that could be more difficult than that.

I will never know the pain she felt—and maybe still feels—to have been torn away from her family and her culture. The memory of her sadness in being so far away when her parents died is still fresh. And it's unlikely that she had the emotional capacity to show her love for me in the way I always needed and wanted. I held that against her for many years and allowed a wedge to form between us. I now understand that she was simply surviving, making the best of her life here, in the only way she knew.

My dad traveled halfway around the world to offer our family a better life. He was a hard worker with the highest professional ethic and impeccable integrity. I am grateful for his sacrifices, but more than that, I appreciate every opportunity and life comfort that has come my way. In the States, we have so many advantages that my parents' culture did not offer—not only major opportunities, like steady jobs and home ownership, but also small amenities, like clean public restrooms, ice, and air conditioning.

I think that watching my parents take all the opportunities they could, and do so with gratitude, allowed me to do the same. They provided excellent role models for me throughout my life.

Seeing what my dad built propelled me to work hard at my education and in my career, not only to support myself but also to contribute to my family. I knew from an early age that I did not want to simply survive; I wanted to thrive by walking into my purpose and becoming the best version of myself. I wanted to enjoy life fully, buy nice things, and take fun vacations. And I wanted to be a contributor, not just the beneficiary of someone else's hard work. That is the essence of what my dad taught me.

My parents' income was limited, so they were frugal but resourceful. And there was a clear distinction between needs and wants. We always had the clothes and shoes and school supplies we needed, but my parents would never splurge on themselves because, to them, they wanted to make sure my siblings and I were provided for. They considered it wasteful to spend hard-earned money on themselves for things that were considered luxuries. However, the limited income did not stop my parents from giving us what we wanted within their means. They were able to buy us things on sale or sometimes splurge, like the nice Gucci watch I received in college that they generously replaced after the dorm cleaning lady stole it. They taught me the value of money and how hard it was to earn it but that it was OK to enjoy it within reason.

My parents taught me the meaning and value of family. It was hard to grow up without our extended family nearby, and oftentimes I was jealous of friends who had cousins or grandparents around. I now understand how incredibly lonely my parents were and how disappointed they were when my brother and I moved away from our hometown. My

dad came here in the hope that we would be a nuclear family that lived in the same town, even if not in the same house. And though I live only three hours away from my parents, I sometimes feel a sense of guilt that I abandoned them. My desire to live a bigger life conflicted with staying in my hometown, so I knew I had to work extra hard to succeed and make them proud.

How could I waste the painstaking journey my parents made to create a better life for future generations? That was—and is—never going to be an option.

Reflection

- In what ways do your past and your parents' past shape you?

- What kind of hardships did your parents face, and what kind of role models did they provide?

- Can you feel compassion for their shortcomings by acknowledging that they did the best that they could with the information they had?

- If you are the child of immigrant parents, can you identify any parts of your parents' culture that are ingrained and contribute to who you are?

- Each new generation is going to find aspects of their parents' ways of life that they choose to take and make better. What parts of your parents' past have you been able to honor?

SEARCHING FOR IDENTITY

"I realized I was working so hard to blend in that even my voice and grammar sounded white. This revelation made me sad."

S ince the first colonists set foot on American soil, immigrants have struggled to balance blending in with maintaining the cultural heritage of their homelands. That struggle is evident in the discrimination, segregation, and violence we've seen throughout our nation's history. It feels strange though; for the immigrant, overcoming this obstacle is an intimate and very personal process, but our society makes it so very public.

My dad was a textile engineer. When he came to America, he landed in New York City and then attended school in Massachusetts, securing his first jobs in Connecticut and Maryland. All the textile plants were in the South, so he

eventually put down roots in Greeneville, Tennessee, a small mountain valley town in the eastern tip of the state. He ended up getting a high-paying job at a big pulp paper plant there. I would always get upset with my father, over the years, because I always wished I grew up in New York City. I joke that my soul was born there.

Greeneville was a sleepy town that prided itself on the extra "e" in its name, being the adult home of Andrew Johnson, and having a winning high school football team, the Green Devils. It was a safe place to grow up. We never locked our doors, and we kids were allowed to play out in the streets of our neighborhood all day and evening. Being one of only a handful of Indian families, everyone knew us by name.

One of our Indian neighbors, the Kumars, had two daughters, Nita and Ruchi, who became lifelong friends to me. Another Indian family owned a motel in town. Our three families would hold gatherings on weekends, with the mothers making big Indian meals to share. It created a feeling of belonging and the familiarity of home for my parents, who deeply missed their community back in India. The biggest thing missing was having access to our extended family. I never got to know my grandparents, and they never really got to know me. We were known as the American grandkids and cousins who would visit three months at a time each summer of our childhood. I was always envious of my American friends who had close bonds with their extended family, especially their grandparents.

Instead, we knew most of the Indians in East Tennessee, and we would travel between Newport, Kingsport, and

Morristown to visit as many of the families as we could. Because these families came from different parts of India, none of our parents spoke the same dialect or participated in exactly the same customs, but they shared a special bond: they were fresh-off-the-boat Indians looking for friendship and a sense of community.

We had a great childhood. Our parents did an incredible job of assimilating into this small Southern town, and we celebrated all the American holidays. My parents always hosted Christmas Eve parties for the neighborhood in our home. My dad would invite everyone—he loved welcoming people and making them laugh. Holiday parties were always full of joy, laughter, Christmas music, and plenty of Scotch for the adults. And after everyone left, we would stay up late to open our gifts. My dad made sure that every detail was taken care of for these festive family celebrations.

We fit well into our community without any problems or concerns. Our next-door neighbors, the Kites, were a lovely family that took us in and showed us the ropes of American life. The daughter, Kimber, was six years older than me, and I looked up to her. She spent a lot of time with my mom because she wanted to learn more about the Indian culture. And, in turn, I loved it because I wanted to learn more about the American culture. One of our neighbors, the pastor of the First Christian Church in town, was especially kind to us. He convinced my devout Hindu parents to allow us kids to go to summer Vacation Bible School. I have fond memories of that experience. I loved learning about Jesus, making crafts, and eating

snacks with new friends. As a child, I looked forward to it every summer.

My parents wanted the best possible life for my siblings and me, so they entertained all our childhood curiosities. For example, at the age of four, I fell in love with style, fashion, and design. I asked my mom to take me to Woolworth and buy me big, mint-green earrings and mint-green eyeshadow (the "it" color in the early 1970s), which she graciously did. My mother also liked to dress me in flamboyant Indian attire, always paired with ruby-red Mary Jane shoes.

I was a fashionably dressed little girl with a cunning mind and a bold personality. At a young age, I began developing leadership skills, especially with my twin brother. Poor Neil—he believed everything I said. He was always getting into trouble because I'd set him up or blame him for something I did.

My dad taught me the essence of living a beautifully curated life. His prized possession was his Emilio Pucci Limited Edition Silver Lincoln Continental. I remember him washing and waxing that car every weekend. Dad wanted to enjoy the rewards of his hard work and celebrate the freedom of choice he'd earned in this new country. While he rarely splurged on himself, he definitely bought his dream car and got a good deal on it. Coming from a country where negotiations are involved in every purchase, my dad knows how to negotiate, and he is both book smart and street smart.

He got to travel many parts of the world, working for a paper pulp manufacturing company. My most memorable

trip of his was his trip to Japan. I asked for him to bring back a Japanese doll for me, which he did, along with a kimono. We were exposed to different cultures very early on. Because of that, I knew that Greeneville was just not where I would ever end up.

While growing up in Greeneville, my best friends, Anna, Leslie, and Tara, introduced me to all kinds of American culture, including dance, dollhouses, fashion, and music. I learned to twirl the baton and play the flute. My parents made sure that I had whatever was popular at that time or whatever helped me fit in, whether it was a music record, a preppy fashion item, or a Madame Alexander doll. We were given all we needed, and we were never denied anything we wanted to try. During these young, innocent years, life usually went just the way I wanted it to.

But not always. I decided to play my first real team sport in the fourth grade. I asked to join our community recreational center's girls' basketball league along with my neighborhood friend Kristi. Kristi was long-legged and athletic. I was short and a girly-girl, but I was sure I could throw baskets all day long like Michael Jordan. That was not the case. When my parents came to see me play our final tournament—the one and only time they came to a game—I was benched for the entire game. That sense of failure and embarrassment stuck with me for a long time. And it was the reason I never tried another team sport outside of a physical education class again.

Throughout my elementary school years, I was ignorant to racism. In fact, I played the lead Indian princess in my

first-grade school play, and my peers thought it was cool, as did my teacher, Mrs. Kidwell. Like everyone around us, she seemed to appreciate the culture, clothes, and food of India.

My only Indian best friend, Nita, and her family moved around the time I got into middle school. I was devastated. She and her sister were my only Indian friends in town. I ended up befriending Kelly, the girl who moved into Nita's house, and Kelly and I developed a great friendship. However, there was something about Kelly that I felt she "took away" from me. It was not Kelly's fault that my only Indian friend moved or that Kelly's family bought her house, but I subconsciously took it out on her, and one day I decided to pick a fight with her. I told her I wanted to fight her at the bus stop. I mean physically fight. Now, Kelly was two heads taller than me, an athlete, and had an arm cast on that day. We got off at our stop, and half the bus got off to watch. I was scared like a chicken, and I told Kelly she could hit me first. And boy did she. She whacked me pretty hard with her casted arm. And we both got into big trouble. My rebellion started showing up in middle school, and I did not understand why at the time.

Middle school was the most awkward stage of my life. But let's face it—it is everyone's awkward stage. I wanted to be popular like DeAnna and Maxi, the pretty, white, cheerleader types. In fact, one of my fondest memories from those years is when DeAnna invited me for a sleepover. I was in heaven, and I still remember to this day the details of that sleepover. I wanted nothing more than to be acknowledged and recognized by those pretty, popular girls, and she made me

feel special. She never made me feel different, and instead she welcomed me in.

But a pivotal, painful incident occurred when I was in seventh grade. One day, on the way home from school, I was walking down the aisle of the school bus to get off at my stop when a mean boy named Dan tripped me. In front of everyone, he shouted, "Your face is dirty!"

In that moment, I wanted the earth to swallow me whole. For the first time in my life, I wished that I was white, blonde, and blue-eyed, and from that point forward, I always made sure that my face did not get too dark in the sun. I went to great lengths to stay as light skinned as I could. I made a point to wear SPF 100 sunscreen and sit in the shade in a hat anytime I was out in the sun. I became overly conscious about being out in the sun, so no one would ever tell me my face was dirty again.

About this time, I began to realize that I wanted to be more than what I was in this small town—a brown girl in a sea of popular, white girls. In those early days, I would daydream about being a Dallas Cowboys Cheerleader, which at that time was a coveted position for young girls. However, for me it was more about being recognized as beautiful *and* talented. I knew that I'd have to leave Greeneville to find fulfillment. Unlike my conformist siblings, I was a rebel, a black sheep, and a boundary pusher—a trailblazer like my father. I loved looking at glossy travel and fashion magazines. And our summer trips to India had shown me what a big world it was. Planted deeply inside my heart was an aching desire to experience life fully. I was angry that my dad did not

land at Ellis Island and stay in New York City, where I'd find the kind of culture I longed for.

Then one day, when I was in eighth grade, my dad told us he had received a promotion. We were moving to Raleigh, North Carolina! From my joy and excitement, you would have thought we were moving to New York City.

Moving to a bigger city, where we were able to custom build a house, was a big deal for me. Although our new house was modest and strictly middle-class (our family of five lived solely off my dad's income), to me it was a mansion straight out of France. My dad let me help pick out the details of the exterior and interior. My father also was an avid gardener who tended a large, bountiful garden for many years. I did not get my father's green thumb, but I learned to appreciate nature's beauty through his work.

Attending a Raleigh city high school exposed me to more diversity, and I gained confidence. I was enrolled in a magnet school where 40 percent of the students were African American, and the rest represented a variety of backgrounds and ethnicities. It felt like all the races, ethnicities, and socioeconomic groups blended seamlessly in that small utopia. I wasn't in the popular crowd, the jock crowd, the artsy crowd, or the smart crowd. I was somewhere in between, so I could easily move among them all.

Furthermore, Raleigh had a Hindu temple. Typically, temples are only built in larger cities with a significant Indian population. I finally felt like I could meet others like myself, which helped me discover my identity. During

those first years in Raleigh, our family went to the temple frequently, and my brother and I even joined the youth group there.

I met Kanku, my best friend in high school, at our Hindu temple. She lived in the small suburb of Garner, where she may have been the only Indian person at her high school. Kanku looked more Italian than she did Indian, and she was often asked about her ethnicity. We shared our confusion about identity. We both wanted to adopt the American culture of dating and independence, yet we felt bound by Indian values and customs. For example, we had to accept that we were not allowed to date, but as a compromise, our parents allowed us to go to homecoming and prom. For our families, fun was really considered a frivolity, and dating did not exist.

It was comforting to know that there were others who felt the way that I did. We both came from a culture that did not really show a lot of affection in the way of touching, kissing, or hugging. Furthermore, the culture was not big on the Western ideas of praise, because everything was based on duty. We were expected to excel in education, because education is the foundation of a country that believes that education is the way out of poverty. While I wanted to identify with a particular culture, I couldn't. I did not consider myself fully Indian or fully American. I was constantly trying to fit myself into a box.

Having been able to travel at a young age helped me to see that the world was so much bigger than this box. And during my high school years, my love for travel grew. I was fortunate

to be able to go to Paris and London on a French Club trip. Europe showed me art, fashion, and glamour.

My last trip to India in 1989 showed me the dichotomy of abject poverty and extreme riches. I had asked my dad to take me to the Taj Mahal. In those days, traveling in India was not easy, especially if you were traveling from the south to the north. But my dad and one of my favorite cousins, Sunil Prabhu, made it happen, and we stayed at the famous Tajview hotel. The story of the Taj Mahal and the physical structure itself left me in awe. The stark contrast between the poverty outside the gates in the city of Agra and the riches inside this large marble monument was startling.

When I returned home, I was not the same person. I had seen something that my peers only read about in history books. I came back empowered, realizing that I come from a deeply rich culture and that my differences hold great worth. The Indian culture is one of the oldest in our world, and it embodies values deeply tied to family. The spices are heavy with complex flavors, and the fabrics are colorfully ornate. The architecture has a beautiful history and unique design. Nothing about India can be described as vanilla or boring.

I also came back with a compassion for humanity that created a new depth to my personality. To see the significant difference between the slums and the mansions and the vast chasm between the impoverished and the wealthy in India is something that we cannot fathom here in this country. Acknowledging the existence of such

harsh inequality in this world forces us to see how good we have it where we are.

The caste system persists in India, and I grew an affinity for the "untouchable" class (the lowest level). I did not see the child beggars on the street as different from other kids—they were human, just like me. My compassion deepened in a way that would not have happened in America. I came back to the States with zero tolerance for treating other human beings as if they were "less than" in any way.

As a Hindu of Indian origin, I've experienced religious bigotry here in this country. I was in my twenties, working at a logistics company, when I had a conversation with a colleague named Les who sat in a cubicle across from me. Les was the kind of guy who wore half-sleeve shirts with ties. We'd been talking about religion, and he asked me about mine. When I told him I was Hindu, Les looked at me without any kind of facial expression, and said, "You're the devil's seed." At the time, I had no idea what he meant, but he was evidently referencing some religious teaching that Hindus were born out of the devil. I immediately asked to be moved to a different cubicle.

Around this same time, I began dating a white guy named Chad. He was a charming Southern gentleman, and we had a wonderful romance for a month. I liked him, and he liked me. But then, one day, he suddenly explained that he could no longer date me; his Southern Baptist, small-town family would never accept me. Talk about heart crushing. He did me a favor by not stringing me along, but the rejection hurt deeply nonetheless.

No matter how cultured and educated I was, being brown was still a barrier in the white South. I carried that burden for a long time, and as a young adult, I always felt inferior to my white counterparts.

I also experienced a particular form of prejudicial treatment within my own race called "colorism." In the Indian culture, the lighter skinned you are, the more marriageable you are, the more educated you are, and the more attractive you are. It is assumed that you come from money. In the game of arranged marriages, skin shade leads any marriage proposal.

When I went back to India every summer as a child, the first thing my relatives would comment on was how dark I had become. I thought that being tan or dark was unattractive in either culture, until I realized that tanning is a multibillion-dollar industry here. It baffled me that white people actually want to be brown! The older I got, the more white-skinned people would compliment me on my skin color. That is the irony of feeling less than when you don't have white skin.

Sadly, I never felt a part of my own ethnicity. My family originated from a tiny town on the Southwestern coast of India, Mangalore, about 220 miles west of Bangalore. They speak a small dialect called Konkani and are a part of the highest caste in the Indian caste system, GSB Brahmin. There are only 340,000 of us in the world.

As I was growing up, most of my American-born Indian friends didn't understand my mother tongue—they still don't. Konkani is not based on the national language, Hindi,

like most of the Indian languages. So I grew up with a complex about the language I spoke.

I've experienced various forms of rejection amongst Indian people. Many of my parents' "friends" had hidden agendas based on their animosity toward our social standing as Brahmins and constantly tore us down rather than build us up. In fact, some of the Indian mothers would say nasty things about me to my own mother.

My most vivid memory was in high school when an auntie (which, out of respect, is what we call all female Indian adults) told my mom that she should be ashamed that I was wearing a strapless dress to my junior prom. (Oh, the horror!) My mother, being the kind, respectful woman she is, remained silent. Because she did not defend me, unbeknownst to her, she furthered my shame.

It was around that time that I grew a deep resentment for Indian people from India. This resentment toward my own race didn't come unfounded. I experienced real hate from my own people. They were just as judgmental and racist toward Indian Americans as some of the white people in this country.

Knowing that the heart and honor of one's family is the parental unit, many of my Indian haters would go to my parents to share something I was doing or make up stories about me in order to shame me and get me in some kind of trouble. I had an Indian college roommate who wrote an anonymous letter that was filled with lies about my behavior on campus. The reason she did this was because she was intensely jealous of the fact that my parents, unlike her own,

were so good to their daughter. Shaming me to my parents led to a deep conflict within me regarding my own race that, years later, I needed therapy to work through. I did not deserve to have others' hate in my heart.

My identity became more confusing during my young adult years—I didn't know where I belonged. At some point, I made the decision to identify myself as a "coconut"—brown on the outside and white on the inside. I avoided most Indian people from India at all costs because I decided that they didn't get me and were jealous of me for having been born here and Americanized. At some point in time in my early adulthood, I wanted nothing to do with them. My dad would always quote Shakespeare and say, "To thine own self be true," and I never fully understood that until much later in my adult years.

Many years later, in 2017, I moved into a new home and neighborhood in Charlotte, North Carolina. I was elected to the homeowners association (HOA) board, overseeing eighty homes in my neighborhood, 80 percent of which were owned by Indian families directly from India. Talk about irony!

So here I was in a neighborhood where the vast majority of residents were Indian immigrants. Most of them had no idea about being part of an HOA as they were first-time home buyers. At the turnover election meeting, the room was filled with 90 percent Indian males. Their wives did not come. I was disheartened, thinking that I was not going to be voted in. In fact, I assumed that they would elect Indian men they knew, especially since I tended to keep to myself

and knew only my immediate neighbors. But I won that night! I was one of the few candidates who had experience with an HOA, and I delivered a strong speech.

After the election, most of the men came up to shake my hand and congratulate me. I had them all wrong, and I felt guilty for judging them based on my own past experiences. I decided I needed to meet more of my neighbors, making a conscious effort to have conversations with them. As I began to see how kind and warm they were to me, my heart started changing. I realized that I could turn my longstanding belief about "fresh off the boat" Indians into an opportunity to help them and, hopefully, grow and learn from them. I came to see that in their eyes, I represented who their kids would someday become. And they saw me as someone who bridged the generational gap.

It wasn't until I turned forty that I saw my skin color and unique Indian-ness as assets. By that time, social media was taking off, bridging the divide between America and the rest of the world. India was becoming mainstream. I realized that as a nonwhite American, I automatically had culture, and I could blend in with all races. Friends remarked how lucky I was to not need to lay out in the sun or pay for spray tans. I noticed that my mom, now in her seventies, barely had any wrinkles, and I appreciated that I would probably look younger longer as well.

Though I did not experience outright racism again, I had folks along the way tell me that they saw me as white. The only thing different about me was my skin color. I realized I was working so hard to blend in that even my voice and

grammar sounded white. This revelation made me sad. And I finally decided to embrace the person God made me to be.

Though my experiences with prejudice happened many years ago, I still feel an underlying need to prove myself. If I could go back in time, I would tell my younger self that her true beauty was in her racial difference and that her uniqueness would be her biggest asset later in life.

Words—whether positive or negative—are powerful, and their effects can last a lifetime. The negative words I heard subconsciously defined me until I understood that when others said something hurtful, it was because they had a deficit or wound within themselves. Their attempts to shame me had nothing to do with me. I wish I knew that sooner in my life. It took me a long time to stop taking things personally.

Also, I've learned that many people are afraid of others' differences and simply don't know how to deal with their discomfort. Some are even taught hate in the home or have watched it modeled in a way that they consider it to be cool or acceptable.

I have learned a lot about "offend-ability," which is the level of offense you take when someone says something that you don't like. What someone says is more a reflection of them, not you. That took me a very long time to understand. My offend-ability has significantly declined in my later adult years because I have come to know and love myself. We have to really look into the heart of the person to understand intent. Sometimes intent is meant to harm, and sometimes it is not. Either way, we are all here equally, and everything in this beautiful world is equally ours to get.

Wouldn't life be boring if we all looked the same or brought the same experiences to the table? Don't miss out on the beauty and diversity of humanity. We can all learn so much by surrounding ourselves with people who are different from us.

People come into and out of our lives for reasons, and each holds a lesson, whether positive or not. It's a shame that, to this day, skin color separates us. I have learned to appreciate the richness of our differences and seek out people who are different from me. Wouldn't it be amazing if we all could see each other as one human race?

Reflection

- I imagine that someone from your childhood probably said something that cut so deep, you remember not only that person's name but also their exact words. You may have heard the expression: "Hurt people hurt people." What might you say or how might you respond to that person from your past today?

- We all have something about ourselves that we consider a flaw to be ashamed of or hidden from others. How might you reframe this trait or aspect of yourself to see it as an asset or something of unique value?

- Have you ever witnessed any form of racism, and if so, how have you handled it? Do you think we should step up and step in?

- Have you ever been a target of any form of racism? If so, how have you handled it?

- Do you find that you tend to gravitate toward people who look like and act like you?

GOING WITH PLAN B

*"Every disappointing failure has led me
to a better place. I've learned to think of
disappointments as road markers that will take
me down the road I'm supposed to travel."*

I am a planner. We planners plan out everything, from the outfits we are wearing the next day to how each minute of the day will be used. Imagine the slap in the face I got when life let me know early on that I did not have any control over what I planned.

When we first moved to Raleigh, I knew that I was in the home state of my dream college, the University of North Carolina (UNC) at Chapel Hill. And it was in Raleigh that I eventually found a new self-confidence.

We moved there at the end of my eighth-grade year, so that my twin brother Neil and I would be able to start high school fresh and make all-new friends. I chose our home high

school in our neighborhood, and he chose a magnet high school about thirty minutes away. During our freshman year, he always returned home from school joyful. Sadly, that was not the case for me.

I felt out of place in my school, which was located in the predominantly white, upper-middle-class neighborhood where we lived. It was hard to make friends when most everyone grew up with each other and had been classmates throughout the previous years. I was jealous whenever my brother described how diverse and accepting his school was. Because it was a magnet school, it was located in a lower-socioeconomic-level neighborhood, and it attracted bright students of many races and nationalities.

So sophomore year, I switched. The next three years of high school greatly boosted my confidence. My brother and I gained popularity even though we weren't in any particular group—we were in the middle of all of them. The nerds liked us, the creatives liked us, the jocks liked us, the cheerleaders liked us, and the neighborhood kids liked us. By the end of senior year, our house had become the favorite gathering place. According to our friends, my brother and I had the "cool house" and the "cool parents," though regretfully, I didn't see it that way at the time.

My parents came to see me on the field when I made the homecoming court that same year. They sat in the stands, and I'm ashamed to say that I never once went to look for them or acknowledge them. I was embarrassed of my parents and was more concerned about the kids at school thinking I was cool.

Though I was a selfish daughter, I know my parents kept loving me, and they allowed my brother and me to enjoy our high school years to the fullest. I kept my grades up and never let my family down in that area, mainly because education is such a focus in the Indian culture. During those three years, I appreciated the benefits of being in a high-performing, diverse high school. What I didn't realize was that I would be up against some pretty high SAT scores at graduation time.

I made sure I took all the right college-prep classes, but my pure joy was in art. My favorite class in high school was Commercial Art where I spent happy hours working on fashion illustrations and beauty ads. I collected *Seventeen* magazines and tore out all the beautiful advertisements.

My father instilled in me an appreciation for aesthetics and beauty in our surroundings. He had our home in Raleigh custom built, making sure it was full brick and French-inspired. He let me help design our house and pick out many of the colors and details, both inside and out, including the garden.

I loved anything to do with creating. So it was no surprise that at age sixteen, my first job was in a craft and hobby store in the mall. My entrepreneurial spirit was stirred there. I created all sorts of jewelry and craft projects in the hope that one day I could turn my artistry into a business.

When I received my first paycheck, I took a large chunk of the money ($70) and bought my first piece of artisan jewelry. It was a copper bracelet with enamel overlay, decoupaged with a cool ocean theme and Swarovski crystals.

My mom was furious with me. She thought it was a ridiculous waste of money.

One thing my mother and I never saw eye to eye on was the value of art, fashion, and beauty. Because my mother came from wealth and began her new life in this country with barely two pennies to scrape together, she developed a sense of resourcefulness and practicality with how she spent our money. While she was extremely generous when it came to providing needs and wants for us kids, she never spent money on herself, and she certainly did not buy items that were as frivolous and impractical as a copper bracelet. I still have that bracelet. For me, it wasn't just a piece of jewelry. It represented a promise that was close to my heart: if I worked hard, I could afford the beautiful things I wanted to be surrounded by.

My deep-down dream school would have been the Fashion Institute of Technology or Parsons School of Design in New York City, but I knew my parents would never pay for something that they did not deem as a fruitful education. So I worked hard to get into the best college I could, and we had many in our new home state. I applied myself to my studies in high school and had a 3.8 grade point average, but I was still considered an average student. I was surrounded by brilliant kids in my magnet school. Still, I was confident that even though my SAT score did not hit four digits, I would be accepted into my dream college, UNC Chapel Hill. So when college application time came, I applied to only two other schools: the University of Southern California (my far-reach school) and North Carolina State University (which was right in my back yard).

The day I received the letter from Chapel Hill, I was prepared to celebrate. Instead, I was devastated. I'd been rejected. They had filled the quota from my high school, and I did not make the cut.

When I went into my part-time job that day, I spent most of my shift in the kitchen crying. And I continued to cry throughout the next week. My best friend Kanku was accepted into this dream school of mine, along with several of my other friends, which only made the rejection harder to accept. For the first time in my life, I experienced failure—a failure so deep, I let it define me for a long time. And when I say a long time, I mean well into my twenties.

I ended up attending North Carolina State University (NC State). There, I discovered who I was and what I was capable of. I wanted to follow my passion of interior design or fashion, but my parents would not pay for something that was so frivolous in the Indian culture. The idea of them entertaining all of my curiosities ended here. They did not want to send me to college only to come out waiting tables; they wanted to set me up for success in my life. And they knew the chances of me being the next Kate Spade were pretty slim.

My dad worked hard to provide for us to go to college, and I was not going to let him down. I was going to excel at my studies so that I could make him proud and do right by him. At the time, I had no idea what I wanted to major in because if I couldn't choose my passion, I had to choose something that I could sustain as a career. Stereotypically, well-educated Indian parents want their kids to become doctors, but I

decided that blood made me faint, and I wasn't interested in the sciences, so that profession was out. I would have to pick another major that would have a high success rate of landing a well-paying job after graduation.

Unfortunately, during my freshman year, my father lost his job. He was laid off by the company where he'd worked for over twenty years, steadily climbing up the corporate ladder. This was the company we relocated to Raleigh for and the company from which he was supposed to retire. He was in his early fifties.

At the time, I was living in my college's most expensive and prestigious private dorm, University Towers. It pains me to write this, but I was selfish and did not want to move back home. So my father worked odd jobs to keep me in school and living in my luxurious dorm. My life did not skip a beat. Dad, along with my mother, made any sacrifices necessary so that my siblings and I would not be affected by this devastating blow.

Seeing how my father was done wrong by a white, high-level, old-boy network caused me to work even harder. I watched him fall, and sadly, he never quite got back up in his mind. I suspect that my dad, now in his early eighties, has never fully recovered from that failure. I knew that I had to succeed and make good grades because my father was paying my full tuition as he struggled to start over.

He eventually got a good job as a quality assurance engineer at the Revlon cosmetics plant in Oxford, North Carolina, a little suburb of Raleigh, but he never regained his status and his place on the corporate ladder. And through it

all, he never showed us his pain. In some ways, I wish that he had because I failed to understand how much he needed me.

In the meantime, I made the decision to major in accounting. The number one accounting professor in the state, Professor Skender, who also happened to be my parents' neighbor, was teaching at NC State at that time. One day during freshman year, my parents set up a conversation between us so I could learn more about accounting and business. I ended up loving my business classes, and I looked to Professor Skender to mentor me.

Under his expert guidance, I thrived in my classes. I loved the idea that numbers could tell a story. For me, putting together financial statements was like putting together a puzzle, and I found ways to apply my creative drive in the business industry. What I didn't know then was how nimble the accounting business would prove to be as I went through various stages of my life. Accounting not only would provide me with a good living, but also would be my pathway to entrepreneurialism.

Both my parents came from business owners; entrepreneurialism was in my blood. My father's father owned a betel nut factory, and my mother's father owned a dye and chemical business in their town of Mangalore, India.

My peers in the accounting major took notice of my achievements and came to know who I was. I had always considered myself to be an average student, but my peers did not see me that way. I ended up passing the CPA exam on the first round in my senior year. For the first time, I felt like I was a little better than average. And that year, NC State had

more students pass the exam than any college in the state, including UNC Chapel Hill.

As I was nearing the end of my college years, I told myself that the world was my oyster. My goal was to secure a job with the number one public accounting firm in the world, Arthur Andersen. Because I had always had a deep-rooted desire to excel, it was important to me to have the prestige that a position at Arthur Andersen would carry.

I needed this achievement in order to fill the hole from my childhood—to show everyone that I had made it. Many of my relatives thought little of me because I didn't have the makings of a "good, subservient wife" and because they thought I was "too Americanized," which to them meant spoiled. Therefore, me landing a prestigious job would prove to both them and myself that I could be *great* at something, not just another spoiled first-generation kid.

And since bragging about your kids was an Indian custom, I wanted my parents to have something to brag about. The only thing is, they never did brag about me because of their modesty and humility. Boasting isn't part of their natures. They just wanted their kids to do well so that we could stand on our own feet and build our own dreams.

In 1993, my senior year at NC State, representatives from five of the big six accounting firms came to campus to hold job interviews. I received offers from all of them. Of course, I accepted the offer from Arthur Andersen.

I could have relocated anywhere the firm had an office, but I wanted to be close to my family, so I chose their Charlotte, North Carolina, location. At that time, the NFL had just

announced a franchise expansion with the Carolina Panthers, the Charlotte Hornets were booming, and the iconic Bank of America Corporate Center was one year old. As I drove to uptown Charlotte and saw the city skyline for the first time, I knew Charlotte was going to be the next big city in the South. It was a place of high growth and opportunity—not just a banking mecca but also a place for businesses to thrive.

During my first year at Andersen, I had mixed feelings about working at the number one public accounting firm in the world. I should have been over the moon. My firm was helping Jerry Richardson build the Carolina Panthers franchise, and there were always awesome networking events to attend. This was going to give me status and open many doors. At that time, starting salaries were $30,000, which would equate to about $54,000 today.

But the work was not all that it was cracked up to be. My first two years entailed a lot of grunt work: copying, faxing, counting inventory, tying out cash, and accounts receivable. I didn't have mentors, except for a couple of women whom I didn't get to work with often. And one of them soon left to become the financial controller for the Carolina Panthers anyway.

I was on a team of men who didn't have any interest in fostering my career. Each team had a partner and manager assigned to it, and staff people like me were typically with the same team for their first couple of years. I was one of a small handful of minority employees in the Charlotte office, and while my peers did not treat me differently, upper management surely did.

Those individuals were part of the good-old-boy network. I was just a number to them. I was put on all-male teams, and when we traveled out of town, it was evident that I was a drag. My presence meant they couldn't go do "guy things," a fact that was communicated to me clearly after one of our trips visiting a client in a beach town. Although I had an appetite to learn, I was never mentored, which was disappointing. I had expected to be treated with respect and set up for success. Instead, I was forced to fend for myself and set up for failure.

I worked hard. My performance evaluations were good, and I met or exceeded expectations for every audit job. Still, after about two years, I was called into my managing partner's office and "counseled out." He delivered a rehearsed speech about how I was appreciated, but it was a matter of attrition, and the office had to let go of a certain number of folks in public accounting. He never brought up my awesome evaluation reports.

I remember that day as if it were yesterday. After that conversation, I hurried downstairs to the lobby of the building and ran outside for fresh air. I sat on a nearby bench and cried. I was humiliated and heartbroken. For the second time in my early adult life, I felt like a failure.

I also felt the burden of having let my parents down—all the money they spent on my education had been a complete waste. I'd proven to be a disappointment to them.

Little did I know that a financial scandal was brewing involving the energy giant Enron, which would, in the years to come, lead to the complete collapse of Arthur Andersen.

The lawsuit against the accounting firm would cause it to close its offices across the world.

The day after I was let go from Arthur Andersen, my family came to Charlotte and comforted me. I knew that everything would all be okay. However, because I had defined myself by that prestigious job, I had no idea who I was anymore. I had identified completely as a CPA in the most prestigious public firm in the world. But I was determined. I would find another great job where I could thrive and move forward.

Twenty-five years later, I still have my evaluation reports from my job at Arthur Andersen. I haven't had the heart to get rid of them, as if they served as validation of my intellect and capabilities. I need to have a burning ceremony and finally let go of that devastating blow.

I let my managing partner define me and my capabilities for years to come. I let him decide that I wasn't good enough to rise to the top of the corporate ladder or one day become a partner. I let him decide that my audit skills were lacking. Meanwhile, I never took the time to realize that he was just another human being who had no say in my life and no right to define who I was.

I experienced high success and high failure in the beginnings of my adult career path. I didn't get into my dream college, but I did receive a first-rate education, was at the top of my accounting class, and passed the CPA exam on the first round. I was hired by the number one public accounting firm in the world. And as devastating as it was at the time, when I was let go, I was saved from the misery of the firm's eventual collapse.

We are not defined by our heritage, jobs, careers, or status. We are not defined by our successes or our failures. We are not defined by others' opinions of us or how they treat us, especially if we are fired or rejected. We are defined by how we respond and who we choose to be in all of those circumstances.

I deeply regret not being there for my father when he lost his job. I was not there for him the way he needed me to be or the way he always was for me. To watch his resilience and strength through that challenge gave me a model for later in life when I lost my first job. I believe that my survival coping skills come from him, and they have served me well.

When I lost my job at Arthur Andersen, the disappointment and humiliation I experienced was probably small compared to what my father had felt after giving twenty years of his life to a company. And unlike him, I did not have a family that I needed to provide for. It was nonetheless devastating. But I was able to pick myself up and press forward.

When our plans get rerouted, we need to learn to trust the new direction. The cliché of "when one door closes, another opens" is true. Every disappointing failure has led me to a better place. I've learned to think of disappointments as road markers that will take me down the road I'm supposed to travel.

Reflection

- What job or career failures have you experienced, and what lessons have they held for you?

- Did your career disappointments reveal any hidden blessings? Perhaps they opened other pathways that would not have otherwise been accessible. Or perhaps they saved you from potential hardship.

- How did you feel when one door closed and you entered a new one that helped you grow further in your career?

- Did you ever have a leader in your career who disappointed you? If so, can you find the positive ways that this disappointment propelled you forward?

- How have you taken your past career disappointments and used them for good so that you change the course?

LETTING GO OF EXPECTATIONS

*"I found a strength inside of me I had
no idea I had. I acted from a survival
mode, which took fear out of the equation
and made decisions easier."*

So many disappointments are fueled by our expectations, and oftentimes we can control how we feel by reducing the expectation gap to zero. I have found most of my struggles have been from expecting something that was not realistic or something we see in movies.

After I was let go from Arthur Andersen in 1995, I went on to work at a Fortune 500 company, Sea-Land Service, Inc., the largest international shipping company in the United States at that time. The company had just moved their headquarters to Charlotte, and they ran hiring ads in the local newspaper. Everyone in Charlotte seemed to want

a job there, and thousands showed up for their open house. I ended up landing one of the coveted positions in the controller department. My career confidence was restored once again.

I thrived at Sea-Land. I went to New Jersey for three months to be trained, spending as much time in New York City as possible around my training schedule. My passion for experiencing culture grew. I loved the vibe of the city and, of course, the international aspect of my new career.

In my job, I was able to meet people from all around the world. I had developed relationships with many through consistent email communication and phone conversations. In my role, I dealt with all of the ports' bills of lading. Being in that job ignited my desire to travel again. I never made the effort to travel when I was at Arthur Andersen—I always found an excuse, like "not enough money" or "not enough time."

There, I met and fell in love with Fred, the man who would become my husband and my son's father. Fred and I became friends before developing a romantic relationship. My family wasn't likely to approve of him anyway. The strikes against him were that he was white, came from a Christian family, and was about ten years older than me.

But Fred was a good person, and we enjoyed spending time together. I assumed that was a good start, and our relationship grew beyond friendship. I had no good model for what love should look like. While I have a great deal of respect for my parents, their arranged marriage was not what I wanted from love. As it does for many

first-generation Indian-American kids, that idea seemed foreign to me.

I can't imagine how they felt or what they went through in the early years of their marriage. They knew each other for only a few hours before getting married, and their parents planned the entire wedding. They moved across the globe together as strangers. The courage and faith they had was enormous, as was their commitment to one another. In no way would I be able to live up to that ideal. Nor did I desire to try.

I didn't have much experience in dating and had never been in love. In fact, at age twenty-seven, I was saving my virginity for marriage. I am a dreamer and an idealist, so my ideas about love were fueled by romantic movies and novels. Growing up in America exposed my siblings and me to a whole new world of dating and romantic love that did not exist in Indian culture.

I believed that Fred loved me, and we truly cared about each other. I was prepared to fight for him and convince my family that he was a good person and that we would have a good marriage. My fight was more about winning and proving myself right than it was about seeing their viewpoints. They saw potential risks in the road ahead long before I did. And their concerns were out of love and care for me. But I was headstrong and didn't listen.

Eventually, they came to love Fred and accept him into the family. They were really more progressive than I gave them credit for and obviously loved me unconditionally to accept him as my husband. They wanted me to be happy

and realized that we were not in the homogeneous bubble of India, so they did not force arranged marriage upon me. My parents' only real concern was that I maintain my religion and raise my kids Hindu as well. I was "semi-Hindu," and Fred was a nonpracticing Christian. He loved me enough that having a Hindu ceremony and "practicing" Hinduism was good enough for him. My parents threw us the most beautiful Indian wedding I had ever seen. My father gave me a very generous budget, and every detail was executed with great care. I had the outfits, the hotel reception, the flowers, the cake, and the Hindu temple ceremony. Most Hindu weddings last several days, but I was able to condense mine down to a one-hour ceremony. The wedding is very colorful and ritualistic, involving a fire, which the bride and groom walk around seven times together. Each step signifies a vow to each other.

After our wonderful wedding, we were eager to start married life. But I became pregnant right away. I was nowhere near ready to be a mom at the beginning of a new marriage. However, as I was being blessed with the ultimate gift, I made the sacrifices I thought a mother should make. I put my career on hold to raise my beautiful baby boy—I wanted to give him what my mother gave me in the early years. And Fred and I sacrificed financially to make that happen.

I held a romanticized image of what our child's birth would be like. I imagined that I would push one or two times and, boom, he would be born. But when my son

came into the world, it was nothing like I expected. After sixteen hours of labor and the unsuccessful use of forceps and a vacuum device, he was born via emergency C-section.

My doctor had no idea that our baby would be too big to move through the birth canal. After exhausting every possible way of helping him to move, they raced me into the operating room and started prepping me. I was exhausted and scared. Carefully placed drapes kept me from seeing what was happening, but I was awake for the entire procedure.

A C-section is like an out-of-body experience—although you don't feel your body, you're aware of everything that's happening to it. I could see Fred's face, the doctor, and the nurses behind the drapes. I had anxiety about not being able to see the procedure, but I honestly don't think I could have stomached it anyhow. It was the most helpless feeling in the world.

Once our baby was finally pulled out, I looked up at my doctor's face. It reflected a mix of joy, relief, and surprise. She couldn't believe how big he was—9.5 pounds, 23 inches—and his thick, full head of hair.

Because my son was so big, the first breath he took caused spontaneous pneumothorax. This condition occurs when the power of the first breath is so great, it creates a puncture in the pocket next to the lung. He came into the world grunting like a toad.

After taking his vitals, the nurses placed him into a bassinet and wheeled him over beside my head so that I could see him. I started bawling. I was able to reach my hand

into the bassinet and touch his tiny face before he was rushed to the neonatal intensive care unit (NICU).

I couldn't visit him for the next couple of days because I was heavily drugged and in a good deal of pain. The first day I saw him, I sat next to him and began sobbing. He heard my cry, looked over in my direction, and started wailing hard. We already had a connection. He was hooked up to so many machines that I was unable to hold him. Sleeping in the nursery among all of the tiny preemies, he looked like a giant.

I remained in the hospital to recover from my own medical complications. After a week, I was released to go home. Our baby was to come home the next day.

However, in another strange turn of events, I developed a bad infection from the surgery and ended up going back into the hospital the very day my son came home. My sister and mother had come into town to help, and they drove the baby home by themselves. It was a very scary time for us all.

It took me a number of months to heal. My mom stayed with us the first four months of my son's life—I was not physically strong enough to take care of him on my own. My dad drove his old Honda Odyssey back and forth from Raleigh every weekend to help. I was lucky to have their support and was grateful that they were healthy and able to be there for both me and my son. I was beat down both physically and mentally; if it were not for them, there is no way I could have made it. My brother and sister helped at that time as well, and I am forever thankful.

My son gave my life meaning and purpose; he showed me what unconditional love is. No one could hurt my son

because I was there to protect him. I felt joy in a way I'd never experienced, the kind of joy only a mother can know. I made the decision to stay at home with him until he was old enough to go to elementary school. For six years I gave all I had to him, and I raised him with so much love that I hoped he would feel it the rest of his life. I wanted to give him the best of both cultures.

During this time, though, something was different about me. I was never able to fully recover after my delivery, and I couldn't seem to get myself together emotionally. I had experienced amazing joy, but I also suffered from all-time lows. I had no idea what was happening or why I felt this underlying bleakness. I knew that feeling overwhelmed was normal for new moms, yet I couldn't believe how difficult it was for me to manage my moods day to day. Furthermore, we had cut our income in half, so we had to live frugally, which produced more stress.

Creativity provided my therapy and my outlet. I threw myself into every type of craft and hobby I could think of, so I could stay busy and balanced. I learned how to scrapbook, cook, knit, sew, and paint—anything to escape the emotional turmoil that was going on inside me, a painful reality that I hid from everyone.

During that time, my entrepreneurial side came out as well. I started fashioning baby blankets and burp cloths to sell. I found a new friend, Dana, who also enjoyed making them, and we partnered in creating a small, informal company called R & R Designs (the initials of our sons). We sold our products at pop-up markets and a store in my area.

And they sold well! I started giving them to friends who were having babies. To this day, moms make a point of telling me that these blankets were their children's favorite comfort item and that they still have them. I believe it's because they were created out of my love—I poured myself into them. Going to a fabric warehouse was calming; sitting at my sewing machine making something of value brought a measure of happiness. I used my creativity as therapy, just as I always have.

I wish I knew early on that I was suffering from postpartum depression. I didn't receive that diagnosis until significant time had passed. I didn't talk about what I was feeling because I felt guilty and ashamed. After all, I was blessed to have my mother stay with me for the first four months of my son's life, and I was able to be a stay-at-home mom. I had no right to say I was depressed. What's worse, no one around me recognized the signs, which were all there.

Unfortunately, the depression kept deteriorating my spirit. I did not know who I was anymore. I was living a life of mediocrity with no plan or direction. This was not how I envisioned my life as a starry-eyed child in Tennessee. It was not until 2005, when I read Brooke Shields' book *Down Came the Rain: My Journey Through Postpartum Depression*, that I fully understood what was going on. The book made it OK to talk about postpartum depression, but it was too late.

Fred and I had grown severely apart. Even though we'd created a beautiful child together, I wasn't feeling fulfilled in our marriage. We tried working on our relationship—we went to counseling and did the things you're supposed to do to save a marriage. But I was checked out, lonely, and

miserable. I knew deep down inside that my husband could not make me happy, nor was it his job to do that. Fred didn't understand what I was going through, and as each year passed, things just got worse. I felt trapped.

Our son was the love of our lives and always will be, so I was torn about what to do. Would I be selfish if I stayed for the sake of keeping a family together, or would I be selfish if I left for the sake of finding my inner happiness? I knew that I was making everyone miserable around me.

My family held several interventions to try to save our marriage. Marriage is so sacred in Hinduism that a woman gets a new first name when she is married into her husband's family. A daughter is considered pure and, therefore, is given away to their husband's family. Once given away, the daughter "belongs" to her husband's family and can never belong to another man's family again. Also, a dowry is given to the groom's family. The daughter's family gives something of value (gold, money, property) to the husband's family in order to ensure that she'll be taken care of. Traditional Hindus consider divorce to be taboo. Divorced women are looked upon as "used" or "secondhand" in the same way a widow is.

Even though my parents did not follow these traditions to the letter, their deep-rooted belief system and their own arranged marriage made divorce very serious business. Given their devout Hindu background, I knew that me breaking up my marriage would create a massive, permanent rift in our family. I could not blame my family or hold it against them, but I would be truly alone in every way moving forward.

Ultimately, I had to choose between my happiness and my family. Finally, my husband and I made the mutual decision to get divorced. I felt a sense of peace come over me, and though there is no such thing as a good or easy divorce, I was blessed to stand on my own two feet.

My biggest concern was how this would affect our six-year-old son and how I could minimize the pain he would feel. The very week we filed for divorce, his dad and I went into school to meet his first-grade teacher. It was probably one of the most awkward moments of my life. My son's teacher sat silently in between us, and you could have cut the tension with a knife. I immediately blurted out, "He and I are getting a divorce," and proceeded to tell her the whole story. It was painful and difficult to talk about, but this understanding teacher, Ms. Lemaster, made it much easier.

Thanks to the support of Ms. Lemaster and her assistant, Mary, my son thrived during this most important year. Their kindness was critical to my son's success in adapting to school, even as we went through the divorce process. I showed up for him in every way possible and volunteered during that year so that I could be with him in his classroom. He did amazingly well in school not only that year but also every year after. My prayers had been answered. Still, I carried a lot of guilt about splitting up our family and about the fact that our son had to go back and forth between two homes.

While I didn't have the support of my family, I somehow managed to sell a house, buy a house, move, co-parent (though not as peacefully as I might have wished), get a job, and learn to rely on myself. Only through God's guiding

hand did I get through it. My parents kept the lines of communication open, but it was not the kind I desperately wanted. They were not pleased with my choice and, therefore, had a really hard time supporting me. They kept in touch with my ex-husband pretty closely, which upset me at the time. I viewed it as them taking sides versus what it really was, which was them keeping the lines of communication open for the sake of our son. He was their first-born grandchild and was favored. They were at a loss because divorce was not something familiar to my family.

My family rarely visited me. For someone who loves to host and entertain family, the pain of this loss was immeasurable. And it has stayed with me. Still, I understand that my family did what they believed was best, so I don't fault them for taking their stance. The love they showed to my son was more than generous. They kept him during all of his breaks and vacations and would consistently stay in touch with him via phone. They would make sure he received wonderful presents during holidays and his birthday and even on regular days when they wanted to treat him. He grew a really close bond with them that shows up even today. I was willing to sacrifice and maintain as close a relationship with them as possible so that my son had a family.

Because I did not experience the bond of extended family growing up, it was very lonely for me. My parents did the best they could by taking us to India every summer and by spending time with our cousins, but it wasn't what I hoped it would be. Back then, social media did not exist, so keeping in touch was more difficult.

The isolation and loneliness of being a single mom and an entrepreneur took its toll on me. Depression hit me in large waves over the course of the next thirteen years. The first five years after my divorce were especially difficult, but I had to stay strong for my son. I was on a mission to find my happiness and healing so that I could be a whole mom for him. Everything in my life mattered because of him. I did not give myself the option of giving up.

It was a cargo ship company, Sea-Land Service, that saved me from the despair of losing my first job. Ironically, much like the cargo ship that brought my father to America, this company opened new and unexpected opportunities for me. It gave me back my confidence; it enabled me to expand into areas that I would not have ventured had I stayed at my first job. It also led me to meet my ex-husband and give birth to my son. My son is my greatest blessing and achievement and always will be.

The difficulty I had with bringing him into the world was something I believe the two of us were supposed to go through together. It set the stage for the future and built a strong foundation for our mother/son relationship and the trials we would go through.

As for my failed marriage, my inexperience and unrealistic expectations about love probably doomed it from the start. I had placed impossibly high standards on our relationship. Also, we did not have God at our center, not in the way I now see He should be, and the foundation of our marriage was never strong. And God was not present in our lives at the time I battled postpartum depression. I now realize that

two good people are not always good together. In the end, I realized our ideas about life were vastly different.

When family ties crumbled after my divorce, I found a strength inside of me I had no idea I had. I acted from a survival mode, which took fear out of the equation and made decisions easier. People came out of the woodwork to help me, even when many abandoned me. God put the right people in my life to help me along the way. I would not be the strong, resilient woman I am today if I did not take those initial scary steps. With them, I found self-sufficiency and strength deep inside of me.

I thank my parents for disapproving my divorce because had they not, I wouldn't have developed the strong backbone that I now have. That resolve led me into future ventures that I would have otherwise been afraid to undertake. I never dreamed that their refusal to support my divorce would create a foundation from which I gained strength and independence.

It took me a long time to let go of the expectations of what a marriage and a family should look like. No one lives a perfect, movie-scripted life. Constantly trying to measure up to these ideals puts undue stress on our already stressful lives.

We are all susceptible to falling down a deep, spiraling hole of depression. It's important to have a strong support system. We all wear masks because we're conditioned to keep our weaknesses to ourselves. This only leads to isolation and further depression, which can manifest in emotional suffering and physical sickness. It is not only OK but also absolutely necessary to ask for help.

In today's world of technology and social media, it is even easier to fall prey to making comparisons; we may find ourselves lacking what others seem to have. Instead of becoming obsessed with what you don't have, be grateful for everything you do have.

Reflection

- Have you ever had a big gap between expectation and reality in your own life?

- What are the things you could have done to mitigate the disappointment that comes from that gap?

- What are the events in your life that did not come close to meeting your expectations?

- Do you feel that your expectations are unrealistic at times?

- If you have experienced divorce, or any kind of family break-up, have you been able to forgive and work to heal from it?

TAKING THE LEAP

*"Leave your ego at the door and forge
ahead because the world needs the
unique gifts you have to offer."*

Sometimes the universe inexplicably forces you to head in
one direction over another, so you have no choice but to
take a leap of faith. I've learned to leap emphatically without
hesitation in those moments. We have one life here, and
being debilitated by fear is a waste of time.

I wouldn't trade my stay-at-home mom years for anything.
I was blessed beyond measure to raise my son and spend
quality time with him in the first six years of his life. I bonded
with him and helped shape his development. I volunteered
at his elementary school. In fact, I was the coolest "Math
Superstar" teacher! And his first-grade classmates loved that I
brought candy to every class. Once I'd set him up for success,

I was ready to get back out into the world and become financially independent.

I returned to the workforce about six months after my divorce. The husband/wife owners of a local public accounting firm graciously offered me the opportunity to work part-time. That allowed me to be there for my son when he got home from school. I will forever be grateful to them. After having been out of the workforce for six years, I had lost confidence in my accounting abilities. But they saw my potential. I felt hopeful about my new life.

I started rebuilding and creating my new normal, happy that I could be present for my son after school and not further upset his routine and life. I found confidence once again in the work I loved and the clients I built relationships with. I was able to have a career and be a mom. It wasn't easy, but I was able to support myself and contribute to providing for my son—we had a roof over our heads and food on the table. I also felt a renewed sense of purpose, once again using the skills I went to school for.

I learned so much about small business accounting and tax. I soaked up all that I could and worked hard so that I could grow within the firm. During tax season, I worked Saturdays, but it was well worth the knowledge I gained in the five years I worked at this company. I learned all of the best practices and operational issues of running a firm.

I admired the way this firm operated—it was something that I aspired to have for myself one day. The husband/wife team had the freedom of not answering to anyone but themselves. Having that kind of balance and flexibility in life

was appealing to me, even if owning a business involved shouldering greater responsibility. I had always yearned to be a business owner; I just didn't know how and when it would happen. That yearning stemmed from thinking creatively. It also had something to do with the lack of respect I had for the authority figures I'd encountered in the corporate world.

After five years of working at the firm, I was ready to work more hours, contribute more to the company, and ask for a raise. I had become used to my new normal and was able to give more of myself. The founding couple was retiring, and they had just named my immediate boss as managing partner of the firm. I went to his office one afternoon with a list of everything I had accomplished in the past five years, ready to make a strong case for why I deserved a raise.

After I'd spoken, he looked directly at me and said, "You're not getting a raise because you're not where your peers are. You were at home for six years." Then he added, "And you'll never make that salary anywhere else either."

I was astonished at what I was hearing, and I could feel the heat rising in my body. It was that all-too-familiar feeling of rejection and humiliation. I knew he was wrong. And I knew all the talent and experience that I brought to the table too.

I looked at him and stated that I respected myself far too much to work for someone who did not have my back. Surprising even myself, I rose up from my chair, calmly said "I quit," and walked straight out the door.

As I headed toward the elevator, I was still fuming. I was hurt, and I was scared. What did I just do? I was a single mom with an eleven-year-old son. I had a mortgage. I had no plan, no potential next job, and no idea what I was doing.

But this was my Jerry Maguire moment—I'd taken a stand for myself. And like Jerry, I decided I would start my own business with one big client, a client with whom I'd forged a solid, ongoing relationship.

That client was Xenia Hospitality Group, owned by three Greek American men: Stratos, Angelo, and his brother Frank. Because I'd been a longtime patron of their original restaurant, I had asked to manage their account when I first began working at the firm. We developed a great relationship. They trusted me, and I had their backs. I had spoken with them a few days earlier, sharing my concerns about the new direction of the firm and my growing unhappiness with my boss. They told me they would follow me, and more important, they believed in me.

As I walked to my car after quitting my job, I believe that God gave me a sign that I was on the right path: a logo and a vision of what my own firm would look like—colors and all—came to me. I drove home, cried it out, and then picked myself up. This was an opportunity—an opportunity to start my own firm.

I had always had an entrepreneurial spirit. The disappointment of "less than" bosses created the outlet I needed. I was going to do this on my own! I knew I could do it better, and I knew I would make more money than my boss told me I could.

So I took my one big client, Xenia Hospitality Group, and started building from there. I did research on entrepreneurship, owning a CPA firm, and finding clients. I had a website built and business cards designed. I shared the news about my new venture and spread it all over social media. I was now my own boss, and I let my entire network know. I also attended every business networking event I could find. I didn't have colleagues or peers to talk to, nor did I know anyone who was on a similar path. I felt alone, but surprisingly, I was not scared.

My first and only client led me to another big client, a restaurant industry consulting firm, owned by a gentleman named Franc. This company enabled me to travel and attend national restaurant projects and restaurant finance conferences in Los Angeles and Las Vegas. Franc and his lovely wife taught me how to create processes and run a service-based firm with a team, as well as how to enjoy the finer things in life.

They also taught me about emotional intelligence and a lot about myself. I met some cool folks and grew tremendously. Franc stretched my abilities and believed in me so that I could believe in myself. I shed many tears from the stretching, but I had a blast too.

Ultimately, after about two years, I realized that my dream of owning my own company did not align with what Franc needed, and we amicably parted ways. But I will be forever grateful to him and his wife for taking me in as family for the first two years of my business. These were incredible growth years in my career as an entrepreneur.

In the past, I was often criticized for being a boundary pusher and a black sheep. I was in no way the proper, subservient Indian girl. I had a loud laugh and a loud voice, literally and figuratively, but I was expected to be quiet and not heard. Some members of the Indian community supported me, but many just didn't understand me.

I was sometimes told I was not a regular CPA in the industry because I was "colorful." I once had a colleague tell me, "We can hear you walking down the hall." I believe that these personality traits built me up to become a leader one day. I was someone who chose faith over fear, and I was not afraid to be different and carve my own path.

I had yet to find a mentor in my career, so I sought out people I could learn from. I knew finding mentors was vital for my future success. One of my first female mentors was April. April had her whole life together in my eyes, so naturally I looked up to her. April invited me to an entrepreneurial group comprised of a handful of other folks. It was like a secret mastermind group. In that first year, I felt green and clueless—there was no way I was ever going to be where those business owners were. Being in a room of successful entrepreneurs was one of the most intimidating experiences I had ever faced.

But while I had no idea what I was doing in that first year, I presented to the world that I did. I dressed the part, I played the part, and slowly but surely, my client base started growing. No one knew that I worked from my kitchen table for the first four years, or that I then moved to my hallway nook for the next two, or that I finally set up a desk in my

son's room. They only knew that I appeared confident and capable. (And I was never interested in a bricks-and-mortar business anyway.)

I strongly believed that stay-at-home moms represented a rich, untapped pool of talent, so these women were the first people I hired as employees or independent contractors. I was determined that I would never make people who worked for me feel the way my old boss had. (Incidentally, I ended up running into him a few years later, and it provided a sense of closure. He apologized for what had happened and what was said. We made amends as professionals.)

I read all the business books. The fact is, I went through many mistakes and did a lot of "let's throw it out there and see what sticks" experimentation over the period of three years before I found the sweet spot for my company. I refined my brand as I came into more income and as I met more people who identified with my goals and could help me. I grew tremendously, both personally and professionally. And I discovered a whole new world of entrepreneurs and business owners. I was not alone after all. I met amazing female mentors along the way through female networking groups, and once again, my confidence soared.

Once I'd determined my niche, I set about my goal to become an outsourced accounting department for small businesses that could not afford a full-time CPA or accounting staff. Other CPA firms had tried offering this as a specialized service, but I built my entire company around

it. I had no idea if it would work. I just knew from my experiences, especially in my last firm, that the market was neglecting the needs of a large group of small businesses.

Some of my Charlotte colleagues were skeptical about the niche I was creating. I once had an older male associate, who had gone to my website to check out my business, ask me how I was making money on what I was doing. I was shocked at the audacity of his question. When I asked him what he meant, he told me that he had tried offering the same kind of services in his traditional firm, with no luck. I answered by telling him that I was just being myself and that I was going to push the accounting industry forward. And I continue to constantly innovate and fine-tune my services and offerings as my business evolves.

My biggest revelation was in realizing that if I wanted to be good at business, I needed to focus on one thing. For me, that was offering outsourced accounting services tailored to small businesses, but my specialty had to be even more specific. My firm focused on what I like to call the "front end" of accounting. This involves setting up my client's accounting system, running it, closing the books monthly, and being a liaison to anyone who would touch the financial sector of my client's business. Once I figured this out, I felt more confident in rebranding myself.

And, yes, the model worked! I established a proven record of success, which enabled me to keep selling my services and expand my client base.

The year I started my firm, a publication called *The Scout Guide* entered the Charlotte market. That book

was everything to me. It was somewhat of a business bible, featuring noteworthy independently owned small businesses in a given city. It showcased the best of the best. Each business profiled had to meet criteria in the categories of character, community, and craftsmanship. This book was distributed locally to many businesses, and each business featured in the book was chosen by the editor. It was a colorful, beautifully bound, coffee-table book. I coveted being in it one day. No CPA firm had ever been included, and I was determined to be the first.

Amazingly, in year seven of my business, my dream came true! I had reached out to the editor and asked if I could be considered. When I didn't receive an immediate answer, I assumed that my firm was not big enough or well-known enough to be considered. But to my surprise, after a few months, the editor contacted me. She told me she wanted to include me in volume 7. This was a pivotal moment for me—a moment of arrival. I felt the affirmation of owning a small spot on Charlotte's map. And not only had I proven something to myself, but also I felt that in some way this showed my old bosses and naysayers that I could make it as a successful business owner. That publication provided the status that I desired for my brand, and it led me to other prestigious publications.

I've been blessed to have built an impressive list of distinguished clients that includes highly popular Charlotte businesses, female Olympic athlete Sara McMann, and well-known country rock band Reckless

Kelly. These opportunities fell into my lap by divine happening, and I've worked hard to serve my clients well.

I have a team of four talented stay-at-home moms, which satisfied my goal of helping that sector of the population. I wanted to give back to these women because I too had experienced the challenges of combining work and motherhood. I also remember how small I felt when I did go back into the workforce and my decision to stay home with my son became a condemnation rather than a badge of honor. Stay-at-home moms are underrated and undervalued—what a gold mine they've been for my business. I stand for all stay-at-home moms and those mothers who want to reenter the workforce.

No one in my family understood why I would be crazy enough to leave a job with a steady paycheck. And why in the world was I doing it as a single parent with a mortgage? Other than my dad's sister (my aunt), no female had done something so bold. My aunt is an ob-gyn doctor and had her own practice in India, but other than her, it was very uncommon for a woman to have her own business. Women took more traditional roles as wives who took care of the family and did not work outside of the household.

As I pressed forward as a new entrepreneur, I had an epiphany: I was my father. I was meant to be my own boss, trailblazing, pushing boundaries, and finding my own way. That gave me fire, and it gave me confidence. I knew the day I left that CPA firm that I had no choice but to make it in business, and I was going to make it at any and all costs. I could never go back to corporate America and place the

fate of my career in someone else's hands. From a young age, I wanted to be more like my father, since the traditional role of my mother had no interest to me.

If it were not for Xenia Hospitality Group, I would not have been able to pursue my dream of owning an accounting firm. They believed in me and stood by my side. To this day, I consider them my brothers.

Owning my own firm meant that I could be selective about my work and the clients I accepted. Through my networking and marketing efforts, I've created a buzz around my name and my reputation. Being a small firm, it took me a long time to get my name out there—I'm up against the big guys and plenty of solo practitioners who have been around a long time.

When I finally had enough practical experience and success behind me, I took an honest look at my business and developed a list of core values. It defines who I am and what my company is founded on. I use this list in every decision I make and apply it to everything that touches my business. If a potential employee or client does not measure up to this list, then they are simply not a good fit for my firm. The list goes like this:

- COMMITMENT. We make sure our clients trust us implicitly to get the work done in the time we promised, and we strive for excellence in all that we do.
- INTEGRITY. We stand up for what is right, and we hold truth in the highest regard.
- HUMILITY. We have the mentality that our individual clients are always right, and we go above and beyond to serve them.

- COLLABORATION. We work as a team, internally, and as a partner to our clients, externally. We take ownership of our individual clients.
- LIFESTYLE. We strive to have balance in our respective lives so that our own goals and visions for our lives are realized.
- RESPECT. We honor each other and give grace to ourselves and our clients. We hold ourselves accountable for our own work.

I can honestly say I love what I do, but most important, I love the clients I serve. They are incredibly smart and passionate business owners from whom I have learned so much.

There will always be champions in your career. They may not necessarily be traditional ones like your boss or your peers; they may be clients or someone from your business or personal network who has mentored you and believed in you. Don't be afraid to seek them out and ask for advice. Remember that there is always someone on your side.

You must build the foundation of your company first, before anything else. That foundation starts with your core values. Core values shape the identity of your company and provide guidance for you, your employees, and your business. They make it easy to weed out potential vendors, clients, or employees. Unfortunately, I failed to identify my company values right way, and consequently, I made many mistakes in the early years of business ownership. I hired employees or engaged clients who were not in alignment with my values. Those were expensive lessons. If you start

by identifying the purpose of your business and create your values around it, you can build an organization that makes you proud.

It is equally important to find your tribe. I was lonely when I started out as an entrepreneur. Find others who are in the same boat so that you can have a support system of like-minded people who can relate to the challenges you face on a daily basis and understand the ups and downs of entrepreneurialism.

It makes me sad when people go back to work after a wonderful vacation and complain that they are "headed back to reality." Many people either hate what they do or hate their jobs or hate their bosses. Why can't your "back to reality" be just as joyful as your vacation? If you are living for your next vacation, it may be time to start thinking about making changes.

Becoming an entrepreneur creates a certain fearlessness. Ask questions and stand up for what you want. Over time, it becomes easier to face rejection. Don't be afraid of the word "no." It doesn't need to hurt you or define you. If anything, it should further fuel you. Asking opens the door to new opportunities.

Being an entrepreneur takes creativity and overcoming a fear of "looking bad." Leave your ego at the door and forge ahead because the world needs the unique gifts you have to offer. Look for what is missing in the market and use your ingenuity to create a new product, solve a problem, or offer a better way to do things. That is how you take your talent and start your own business. In order to stay ahead of the

game, keep changing things up. Add something new and eliminate anything that isn't working.

Above all, make sure that when you make it, you help someone who is just starting out. Always help those below you because there was always someone above you who helped you along the way.

Reflection

- Have you ever been forced to make a decision in your career because someone essentially took away options?

- Can you think of the champions you have had in your career?

- Are you a follower or a leader? If you want to be a leader, or are one, what are you doing to carve your own path?

- Are you letting the fear of failure or the fear of success hold you back?

- Is there some action you can take in order to take one more step toward your dream?

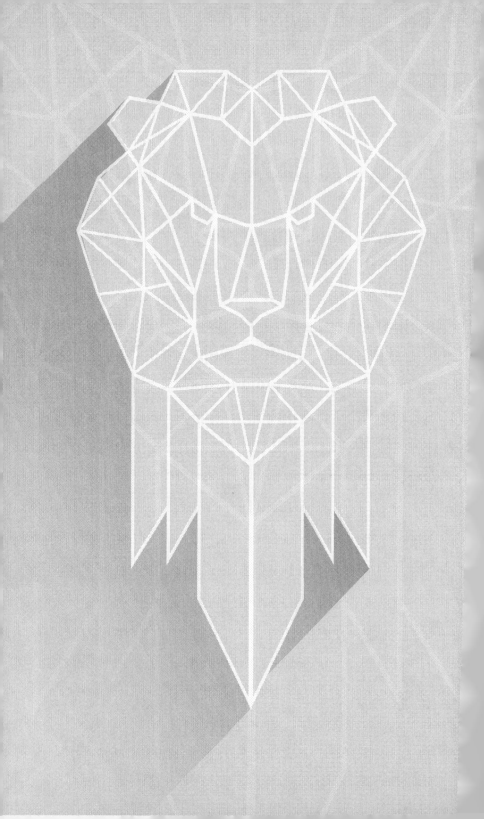

MAKING YOUR OWN LANE

*"I'm convinced that if you build it, they
will come. Don't downplay an idea that is
planted in your heart. Someone somewhere
needs your idea to come to life."*

Getting into a particular club, a company, or a group and how you get in is often beyond your control. But there is more than one way to get to where you want to go, and being rejected from something is often more of a blessing than a curse. At some point, I stopped letting other human beings direct my destiny and forged my own path.

The first five years of my new business venture were a mix of success, stress, and some serious emotional challenges. My divorce had led to a fractured relationship with my family, which was personally painful. I missed the support that I'd always counted on from them. There was also the emotional

roller coaster of business ownership—the unsteady cash flow and the stress of trying to offer my clients outstanding service and be the perfect employer. By this time, my son was a full-fledged teenager. I thank God that Rupen was, and is, such an amazing kid. He got good grades at school, followed all the rules, and had manners. Still, I struggled to manage the high expectations I'd set for myself as a single mother.

During the course of these five years, I went into a gradual downward spiral. Instead of being joyful about the business I had built and the success I had achieved to date, I found myself in a dark place. I woke up most days feeling like I was crumbling inside but knowing I had to be there for my son and for my clients.

The emotional distress that had started as a slow drip eventually, in 2015, become a tidal wave. I could no longer cope with the emotional demands, and I suffered a nervous breakdown. I started attacking everyone closest to me, and it wasn't pretty. I verbally attacked my family. I said things to each family member that I deeply regret to this day—things that one would be ashamed of even thinking. I had no idea who I was, and I felt as if I were having an out-of-body experience. I was living at the intersection of pain and regret.

Worse still, I had a meltdown with my son. My relationship with him was the most important one in my life. And yet I heard myself scream these dreaded words to him: "You can go live with your father!" And then I took things a step further. As I FaceTimed with him, I began

packing boxes of items in his room and told him to come get them.

The very next day, my son came to the house and picked up his things while I was at work. I was devastated. My beloved son was moving out of my house, and it crushed me to my core. It was the day I knew I'd hit rock bottom and that I had a choice to make. I could go down even further into darkness and give up on life, or I could pull myself together and begin to make changes. I would have to work hard to repair my heart and start repairing the damage I had single-handedly created. But this is what I chose to do.

I sought help from friends and from counseling. I needed to do a better job of taking care of myself because I was all I had at that time. And I realized that I needed to feel like I had something to nurture. I decided to look for ways to serve others and give back to the community. I needed to find something to nurture because, all of a sudden, I did not have my son to nurture. So I put my energy into growing my business and finding ways to make a difference in my own community. I had time on my hands that I was not going to waste.

I sought out different organizations where I could volunteer. Also, I began looking for small business networking groups where I could meet folks, learn more about business, and share my experiences with others. I wanted to find my people.

My search was not as fruitful as I'd hoped it would be. While I felt welcome and a part of all the women-only groups, I ran into dead ends with the co-ed ones. I felt that

I needed more than just women's perspectives on business; I needed men's as well. After all, both men and women bring something unique and valuable to business, and I wanted to meet men and women who were like-minded.

Unfortunately, the reason I kept getting rejected from these local co-ed groups was because there was "only room for one." The groups were organized around the idea of including a single member from any given profession. In other words, there was a spot available for only one CPA, and that spot was usually already filled. Even though I kept stating that I was different from a traditional CPA, they weren't interested. The fact is, I routinely partnered with and gladly referred people to other CPAs, but no one seemed to believe me. I was disheartened by this.

It turns out that these co-ed groups were all "leads groups." At the time, I didn't understand the difference between leads groups and other business networking groups. But I learned that leads groups hold formal meetings, and members come to each meeting with referrals for other members. To me, that seemed like a lot of pressure. Also, their practice of limiting the group to one member per profession didn't align with my belief that there is enough to go around for all of us. In my opinion, leads groups operate on a scarcity mentality rather than the abundance mentality that I live by. While these groups work for many folks (and kudos to them), they were not what I was looking for.

I was tired of being excluded and having the nature of my company misunderstood. This irritation fueled me to begin thinking about what a networking group aligned with

my values would look like. It would be inclusive, informal, and all about relationship building, not lead generating. It would include not only other CPAs but also folks of all industries and several of the same. In my abundant-thinking mind, I don't see competition, and I never have. First, there is enough to go around for everyone, and second, each individual offers something unique to a group in terms of how they provide a service or a product.

One morning, I woke up at 4 a.m. with a mission statement firmly planted in my heart. It became the foundation for the networking group I decided to create and is, I believe, a mission statement that Jerry Maguire would be proud of: *to create a transforming networking group for small business owners that welcomes all, regardless of race, religion, gender, or industry; to build relationships and strengthen the community in order to gain referrals and help each other grow our businesses; and to inspire others in learning and knowledge.*

In July 2016, I hosted my first event. Let me be clear: even though I am an extrovert with an off-the-charts "I" (for "Influence") in the DISC personality assessment profile, I am terrified of public speaking. Most do not believe that about me, but it's true.

I found a venue for the gathering and booked a speaker, William, a successful Charlotte-based celebrity clothier. When I first approached William and explained my concept, I thought he would laugh, but instead he said it was a brilliant idea and that if anyone could do it, I could. He was all in, without even knowing much about my plan.

I advertised the event on several different group pages on Facebook. I made it free of charge. And forty people showed up! I was blown away. About half of the people had never heard of me and had no idea what I was all about. Yet they came.

That gave me just the spark I needed to keep going. Just as I had no real plan for starting a business, I had no real plan for starting this group. I just did what felt right and put it out there. I made new friends immediately, who are dear friends today. The likelihood of our paths crossing would have been very small had I not created this group.

Planning and organizing the events came naturally to me. I found that people wanted to share their talents, expertise, and venues. It reinforced my belief in community over competition. It was at this point that I discovered my gift for connecting people with one another. I have always had it; I just never intentionally put it into motion until now.

I am a people person. I derive energy by lifting people up, and being the extrovert I am, I love to make new connections with a wide range of personality types. Through this experience, I have met the spectrum of humanity. Creating this group taught me a lot about myself and others. It taught me discernment, specifically determining whether other people had the same heart and intentions as I did. I realized that leading a group was a big responsibility and that people were watching me.

I did not realize right away how quickly the group was expanding. Before long, it was not just a small community group, but included people from all over Charlotte. That

was a bit intimidating and made me feel uncomfortable as I had no idea who the group would attract. The fact is, it attracted all types of people, and not always people we wanted to attract. Leading the group sharpened me and helped me to mature.

I have organized over thirty successful events in a little over two years, and our Facebook group has over 500 members. The group has truly become a platform for entrepreneurs to connect, collaborate, and grow. I'm proud of the job I've done fostering community over competition. I've watched members forge amazing connections with one another and build great ideas together. The events have given me opportunities to be creative and to shed light on many small businesses and entrepreneurs. Leading the group has sharpened my people skills in the area of discernment and trust. Having my name behind this group, I quickly realized how important it was that our members be of the highest integrity and that they show respect for me, the group, and for one another.

This networking community is by no means the largest or the most well-known group here in Charlotte, and I never set out for it to be that. In fact, I prefer that it remain small and somewhat obscure. My intention was to make a small difference in my community and to create a platform of support for others like me. I have, however, had folks buy into my vision. That is more meaningful to me than any popularity contest. Most all of my speakers have spoken for free because they wanted to give back. This has been more meaningful to me than anything else because these speakers saw my vision and believed in it.

At one point in time, I experienced unforeseen negativity within the group, and several people left. I questioned my ability to lead the group and considered shutting it down. But that would have been me acting out of fear, and I am grateful that I refused to do that. So many collaborations and relationships have been formed between members in my group, and each week, I receive more confirmation of this. This group helped me to heal from the struggle of feeling alone. It gave me something to nurture, and it filled my heart.

And from this venture, a new idea was born: a podcast called *Piece of the Pai*. This series gives me an opportunity to interview successful entrepreneurs in the Charlotte area so that they can share their insights on life and business. I had no idea how to podcast, where to start, or what it took. I just knew that I was itching to do it!

And from the podcast, another goal emerged: writing this book. Never underestimate where your crazy ideas will lead you. Once one idea is set into motion, new ideas are almost sure to come forth!

There is power in connecting with others. As humans we need to connect in order to grow and create and find support. And heal. I have taken every opportunity to connect with people everywhere I go and in every group I have affiliated with. If you create goods and services from your heart, you can sell them to anyone. I was able to secure prime venues and book talented speakers because my passion showed, and people were inspired and moved by it.

I'm convinced that if you build it, they will come. Don't downplay an idea that is planted in your heart. Someone

somewhere needs your idea to come to life. You don't need to worry about how others will respond, but you do need to act. Take the steps necessary to bring your idea into the light. And if you believe in your own idea, then you will get others to believe in it too. All the rest will fall into place.

I feel that God has given each of us a gift that we are to share with the world. Mine happens to be connection. I have the gift of connecting people, and I was gently nudged to create a platform to give that gift away. Our gifts are not to serve ourselves, but for us to serve others. If you do not use your gift(s), you are doing an injustice to what you were created to be.

Not everyone is going to like you, follow you, believe in you, or buy what you are selling. These are not your people. You will lose people along the way, but you will remain on the right track if you stay true to your core values.

Reflection

- Do you believe in abundance or scarcity? Abundance is the only way to really create success within your life.

- Can you find ways in your own life to make an impact by starting or creating something new?

- When you have emerged from a season of crushing, have you used that to create something good, rather than turn inward?

- Have you let others' opinions stop you from setting your ideas in motion?

- Do you ignore the voice of the haters so that you can fulfill your own destiny? The people hating the loudest are the people who have the most fear to dream big and act on it.

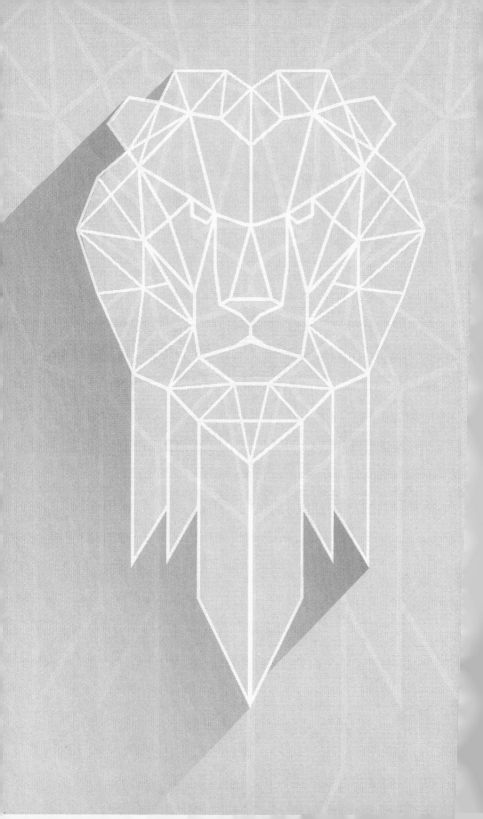

MANIFESTING YOUR DREAMS

*"Most of the time, we are stopped by fear. We fail
to act on the opportunities that come our way."*

Do you ever daydream about your ideal future? Have
these dreams ever felt so real that you could literally see
them happening right in front of you? Have you ever made a
vision board or kept a journal of your dreams to have a focal
point of where you wanted to go? Reality doesn't always end
up the way you play it out in your dreams, but if you work
at it long enough, the realization of your dreams just kind of
sneaks up on you.

After my divorce, I knew that it was going to take me
awhile to rebuild financially and create the kind of lifestyle I
wanted. First off, I had been living in a townhouse for twelve
years, and I wanted to live in a real house again. And second,
I desperately wanted to travel again. I hadn't traveled overseas

since 1989, and I was yearning to go back and explore more of the world.

I've always believed in the law of attraction and the use of vision boards as a source of inspiration. I believed I could manifest my visions. I knew that hard work combined with faith and a whole lot of patience would bring my dreams to fruition. But these manifestations didn't always happen in ways I expected, and my aspirations sometimes changed a bit along the way. Looking back, there are many examples where things simply didn't happen in the way that I'd envisioned.

For one, my experience of giving birth did not turn out the way I thought it would. My beautiful baby couldn't even wear the perfect going-home outfit I'd bought for him because he was too big!

Another example is my entrepreneurial venture. I knew that I wanted to own a business one day, but I envisioned it on my own terms—at the perfect time, with a flawless business plan, and with plenty of money in the bank. Instead, I abruptly quit my job (before being fired) and walked out with no game plan and one client. I had absolutely no preparation for starting a business, but I learned how to do it pretty fast. I knew that my dreams required money, so I hustled hard.

And then there was that young-adult dream of mine of becoming the CFO of some big firm or a partner in a large international public accounting firm. As a bright-eyed college grad who believed that the world was her oyster, I felt like I had failed when my plans were thwarted. As a not-so-young adult, I realized that even though this specific dream did not

come to fruition, a different version of it did. What I'd really wanted was to become a leader in my accounting career. This didn't happen exactly the way I expected, but I *did* become a leader: a leader in my small firm, a leader in my networking group, a leader to my son, and a leader to those whom I've mentored. When I started seeing all the areas of my life in which I lead, my old dream of being some big CFO chained to corporate America sounded absolutely terrible. My dream did not play out the way I had originally wanted as a bright-eyed graduate, but it played out in far more impactful and beautiful ways.

As a new grad, I also had big dreams to travel to exotic places around the world and one day live in a mansion, complete with a pool and guest house. We all want success, and at that time in my life, I defined it as having enough money to live a ridiculously lavish lifestyle. While I don't live in the "rich and famous" style I had dreamed of, I have been blessed to own and live in beautiful homes and have taken many trips around the world. Now, I realize that money may make our lives easier, but it does not buy happiness and peace.

I am coming up on a year living in my new house, a dream home for this stage of my life. Buying it was not in my immediate plans. For one thing, I never thought I could afford a newly built house in the area I wanted. Second, I never thought that my dream house would be built directly across the street from my townhouse, where I could look at it from my bedroom window. And third, my area was so heavily populated that a new-construction development seemed impossible. However, there it was—a beautiful

new neighborhood right across the street from me, being constructed before my eyes. For a few months, I watched as workers took down trees and construction began. I remember looking at the signs with the price range for this development, thinking I would never be able to afford it. It wasn't even worth checking out.

One morning, completely out of the blue, I had a strong thought come to my head that I was supposed to go visit the development's sales center. I was out of town at the time, but I listened to my intuition. I called my realtor at once and told her my crazy idea. She went to the sales center that morning. By the end of the day, I had signed a contract and wired a deposit. I had no idea how I was going to manage this, but God told me it was OK. I had not even put my townhouse on the market, nor had I considered how hard it might be to get a loan as a self-employed single woman. And buying this house would be impossible if I didn't have 20 percent to put down from the sale of my current home.

Though the process was excruciating, my lot, my home, my loan, and my townhouse sale all came through just as they were supposed to. I was able to make the 20 percent down payment on my new house. I qualified for a mortgage. I was afraid of the loan's extremely high 8 percent interest rate but considered it the price I had to pay for being self-employed. To offset it, I quadrupled my monthly mortgage payments during the first year. If I could hold out for one year, I could refinance. I had no idea how all of this was going to come together but once again, I stepped out in faith, not fear, and once again, God made it happen.

The way that the events surrounding the manifestation of my dream were orchestrated was nothing short of miraculous. This house may not have been the dream home I envisioned as a young adult, with a husband and a guest house and a pool, but it was mine! It was all mine, and it was perfect for me. I could decorate it the way I wanted with my favorite furnishings and stylish decor and make it just as beautiful as the mansion I had dreamed of years ago. And to be honest, that mansion is not something I would want at this stage of my life. The bigger the house, the more bills, the more maintenance, and the more stuff you have to worry about.

Also, in the same year I bought my house, I took my first trip overseas in more than thirty years. Travel had been in my blood from a very young age. We took many trips as kids, and my dad nurtured my wanderlust. When I traveled to London and Paris with my French Club trip at age sixteen, I told myself that I would be back as an adult one day. But with a house and mortgage, it seemed that going overseas again would be out of the question for quite some time; I was not anywhere near the financial place I needed to be.

But an unexpected opportunity came to me one day from a good friend who is a French teacher. We were having dinner, and she mentioned an upcoming trip to France and Italy with her students. Before she even had time to tell me the details, I asked her if she needed chaperones. She said yes. And then I said yes, not knowing exactly how I was going to fund this trip but knowing that I would.

Going to Europe with a bunch of high school students wasn't what I would have come up with on my own. In my ideal scenario, I envisioned staying at the Ritz and eating in fine-dining restaurants every night, drinking champagne with an adult or two. My real trip involved staying at inexpensive hotels on the outskirts of the cities, having a packed schedule, and hanging out with teenagers. However, it turned out to be one of the best trips of my life. I was eager to explore, learn, and soak up the cultures of the places we visited. And after almost thirty years, I felt the pure joy of simply being in the country to which I had vowed to return.

After that, I made a promise to myself that I would take one international trip every year. So the next year, I went to London and met up with my cousin after thirty years. And this time, I did stay at a fancy hotel. What pleasure this gave me after so many years of hard work and personal struggles. Overseas traveling suddenly seemed attainable and not just some elusive dream I'd held onto for so many years.

My experiences have taught me that the key to manifesting my dreams is keeping my life in motion and acting on opportunities that present themselves. I've also learned that life doesn't have to unfold in exactly the way I've planned. I can still realize some version of my goals and dreams. It took me a long time to get that concept. I thought that when some aspect of my life fell short of my expectations, that meant I had failed to bring my dreams to fruition. I felt a sense of disappointment that prevented me from enjoying life to its fullest. And I missed the blessings that were already right in front of me. My dreams, in fact, *were* being fulfilled. I can

think of a dozen dreams coming true in my life in which the circumstances were not those of fairy tales. The fact is, dreams don't come wrapped in a beautiful package with a bow.

If we want something bad enough, some version of it can be ours, in due time. Stay focused and watch for open doors. Most of the time, we are stopped by fear. We fail to act on the opportunities that come our way. Say yes to everything that comes your way. Say yes to the desires that fill your heart and mind. Say yes to those dreams, because there will be a way for them to come true. They will probably not look exactly the way you envisioned (unless you have a magical crystal ball to see into the future), but they will come to fruition if you stay on course. It is 100 percent about being rooted in faith over fear. Faith is believing in those things you cannot see. Set your intentions into motion in order to see the blessings that come out of them.

You have the right to go out and experience all the good things this world has to offer. You deserve the same access to the same resources that everyone else has.

Reflection

- Was there ever a time in your life when you didn't act on an opportunity that you think you should have?

- Do you believe in the law of attraction?

- Energy begets energy. Where in your life have you placed energy (positive or negative) and seen the results?

- Are you putting work and action into manifesting your dreams? What does that look like?

- We think our dreams have to look exactly like the way we picture them to be, but have you let go of that idea and allowed your dreams to just happen the way they will?

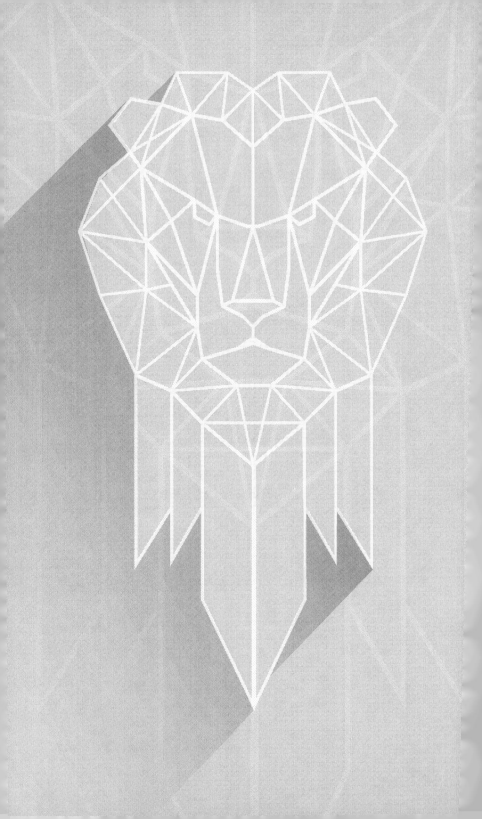

CHAPTER 8

REMOVING THE BARRIERS TO LOVE

"In order to face myself, I had to face who I am inside. I realized that my own heart needed repair—there was still a defensive wall surrounding it."

A basic human need is to give love and to be loved. But for some reason, that is the hardest need to fulfill on our journeys. We are complex beings with feelings and memories that create barriers that keep us from the greatest human aspect that propels us to thrive. We all have them—the barriers that keep us from love. The greatest love we keep from ourselves is self-love. It wasn't until much later in life—in fact, it was many years after my divorce—that I learned that if we do not first love ourselves, we cannot love anyone else.

I was raised by two wonderful Indian parents who did not understand the concept of self-love because they were never

taught that for themselves. At that time, India didn't focus on happiness or love—those were considered elusive, frivolous, Western ideas. Relationships were centered around duty.

My parents' marriage was arranged. They were put together by their parents out of duty and eventually grew to "love" one other. They loved my siblings and me, but their love for us meant self-sacrifice and, once again, duty. They had been raised within a culture in which love is conditional—that is, "you do what I say and become what I want you to be"—so I cannot blame them for loving us in the only way they knew. The word "expectation" is used often in the Indian culture; the word "praise" is not.

I know that my mother came here lost, alone, and afraid as a young, newly married, eighteen-year-old girl. She was never taught to love herself but to sacrifice herself for the good of her parents, her husband, and then later, her kids. Because she did not grow up with a value of self-love, she could not teach that to me. So I grew up not knowing how to love myself.

As a child, I watched the way the women in my family treated each other, and that helped shape my early beliefs about love. For example, right in front of me, my aunt once told my mom I was fat. I was just a young girl at the time. And I watched as my mom said and did nothing. This made me feel unloved. I didn't understand that my mother, according to the Indian culture in which she was raised, was unable to challenge someone who was her elder. This would have been highly disrespectful. During my childhood, there were many situations like this, where my feelings were not considered, and I came to believe that I was not worthy of love. As a result,

I developed a defense mechanism that caused me to act in ways that said, "I am going to hurt you before you hurt me." I was constantly on guard. I expected others to treat me as someone of less value, and I wasn't about to give anyone that chance.

Because I used my mom as a role model and watched her put others' needs ahead of hers to feel loved (because that was what she was taught), I thought that if I put others' needs ahead of my own, I would receive love back. I could not have been more wrong. My mom was taught incorrectly. Sadly, there was more discipline than there was affection in my mother's house.

In the household where my siblings and I grew up, there was parental affection, mostly from our dad. His affectionate nature was rare in the Indian culture, but I think he craved what he had never experienced from his own family growing up. He is the one who taught me about hugging. And to this day, I am a hugger.

Usually, my dad was hard at work being the provider for our family, so I rarely got to talk to him about the uncomfortable stuff, like my feelings. He was traditional and conservative—topics related to love were foreign to him. But my dad showed us love by giving us an extremely comfortable life, buying what he could afford to satisfy our heart's desires, and making sure our educations and weddings were paid for. And we had the best of birthdays, vacations, and holidays. He had a pragmatic love, just as the Indian culture teaches. My dad sacrificed his own happiness to make sure we had ours. He also hugged us a lot, which was

rare for an Indian man of his generation. Both of my parents loved me the best they could, with the tools they had.

I also learned about love from books and movies. My entire life, I had always wanted the fairytale Prince Charming kind of romantic love. That was very different and much more exciting than what was modeled in my own home, where the relationship between a man and a woman began with commitment, respect, and partnership—well before love was even considered. Love was something that grew over time. For my parents, there were no expectations of chemistry or butterflies. (I blame Disney movies and children's books for putting those ideas in my head!) These fantasies set the bar on romance impossibly high. And now, with the entrance of social media with friends posting romantic photos of themselves and their wedding highlight reels, the expectations for what love should look like are even higher.

The issue I faced was not loving myself. Like so many people, I believed that I needed someone to "complete me." I thought that the right man would make me happy and fill my every need, desire, and hope. Boy, was I wrong. And I had it all wrong for a big part of my life.

Everything changed when I became a mother: my view of the world, my view of love, and my view of myself. I immediately understood what unconditional love meant the second I found out that a baby was growing inside my womb. I loved my son so much that he became the center of my universe, and I devoted my full attention to caring for him. But although motherhood had expanded my capacity for love, even my child could not fill the holes inside of me.

I made the mistake, like so many mothers do, of thinking it was selfish to put myself first. Not loving myself enough to take care of "me" put pressure on my son to fill that void. I often felt guilty for being too hard on him or for wanting more of his time and attention, when all he wanted was to be a kid. That need eventually created a fissure between us that I spent several years repairing. Thankfully, my son has developed into an incredible young man, despite me projecting my issues onto him. I give him enormous credit for his strength and resilience.

Through the years, I learned to function as a single parent, and I created some practices for being kind and loving to myself. I thought about how my dad made a point of showing his love for us kids on birthdays and holidays. I decided to take over that role and provide these celebrations for myself. For example, I started a tradition of treating myself to a spa date and a nice dinner on my birthday. I didn't wait for someone else to do it for me, nor did I go into a self-pity mode about being single.

But still, my deepest desire remained. And that was to find a life partner, someone whose company I enjoyed and someone with whom I could share my dreams and adventures. I'd dated on and off over the last thirteen years since my divorce. I would describe these dating experiences as "below average." I had no idea how to love myself, and therefore, I accepted quite a few "below average" men into my life. Nothing serious ever came of my dating relationships. Until Sam.

Sam is an ex-rugby athlete, current high school rugby coach, amazing father, and fun-loving employee-benefit consultant

kind of man. We met through a mutual good friend in 2015 under business referral pretenses. We became friends on social media, but Sam was not on my radar in any romantic way at that time. I casually blew him off whenever he invited me to a business event or a lunch-and-learn. Unbeknownst to me, Sam had been fishing for my attention, but I was clueless. I was still busy fishing in all the wrong ponds.

After a couple of years, Sam gave up and stopped messaging me. He went back into the void of being a nondescript Facebook friend. The only connection we had was when I'd occasionally like something he posted, though he rarely posted. The fact that Sam was someone I did not look at in a romantic way is what makes the story about what happened next both surprising and significant.

I woke up one Monday morning in March 2018 from a very vivid dream. I could remember Sam's face in my dream, and I woke up speaking his name. It was so random. And it amazed me how clear it was. I wondered if this was divine intervention or just something sugary I ate the night before that caused this crazy dream. I had not talked to Sam in a few years. In fact, we had only ever met with each other a couple of times, and those were just brief business encounters with my clients.

As silly as it sounds, I was compelled to reach out to him; I felt that I was being led by God. So I grabbed my phone and began by looking him up on Facebook Messenger. But first, I went to his Facebook page to see if he had a girlfriend or was married—I did not want to put him (or me) in an even more awkward position than I was already about to. I noticed that

our last conversation online was in 2015. How would Sam feel when I reached out after such a long stretch of time and told him I had just dreamt about him? Would he think I was weird? A stalker?

It didn't matter; I had to do this. I couldn't ignore what was on my heart. While I was brushing my teeth that morning, I sent him a message and told him about my dream. What did I have to lose? Within minutes, he responded. And in his message, he seemed pleasantly surprised to hear from me. We developed a dialogue on Messenger. I was more than curious about this dream, and I had an overwhelming desire to see him face to face. So I quickly made up some excuse about needing his insights on rebranding my business. He bought it.

The next day, he texted me with his own idea about why I'd had this dream about him. He had recently been given disheartening information about the future of his job at a big insurance conglomerate, which made him come to a big decision. He was ready to set out on his own entrepreneurial journey. For him, it was business serendipity—our reconnection was about me being an entrepreneur who he admired and respected, someone to give him professional advice. This was not at all clear to me in my interpretation of the dream that I'd had. I felt that the dream was about something more.

We chatted via text throughout the week, and he invited me to an after-party that Friday night. Coincidentally, I was attending an event near the bar where he and the rugby team were celebrating after their match. I told him I'd drop by. He did not believe me until I really showed up.

I was amazed by what happened when I walked into the bar and we first made eye contact. It was instant chemistry for me. I had not seen this guy in several years, barely knew him, was never attracted romantically to him. And then, suddenly, my whole world felt like butterflies. I fell instantly in love with this man. The intensity of these feelings shook me to my core as I'd never experienced anything like this before. From what I knew about Sam, he was a man of integrity, but I certainly did not know him well enough to justify these emotions.

The two of us chatted awhile, and I left soon afterward, hoping he would contact me again. And he did. We met for coffee the next week, and I could tell that we both felt the chemistry this time. This was all so sudden and unexpected—I'm not sure if either one of us understood what was happening. I only knew that I had a burning desire for him to ask me out on a real date. We ended up meeting the following Friday at a restaurant for a four-hour date. It was a lovely evening, and we talked and laughed freely. When he walked me to my car, we hugged and shared a little peck.

I felt sparks. I questioned if I was just lonely or if these sparks were something more. My dream had been so powerful, like God had spoken to me in it, and I had to see if something was truly there. It definitely was. I felt like I was a part of some sort of movie scene, and I had to see it play out.

From there, Sam and I developed a beautiful relationship. Neither of us had dated for several years, and for the first time, my heart was fully open to loving a man and allowing

him to love me. The first six months were wonderful. And I can say that I loved Sam fearlessly.

But eventually our insecurities came out like a bad hangover after drinking all-night birthday shots. At that time, I was in the midst of a spiritual crisis and some intense internal storms. And Sam was struggling with his own challenges. He was a new entrepreneur, and his son (his firstborn) was leaving for college across the pond. We were middle-aged adults, both trying to navigate the unfamiliar waters of a healthy, loving relationship after having been alone for a very long time. Sadly, our relationship couldn't withstand the perfect storm of these stressful events and pressures coming together. We eventually broke up—not once but twice within the period of a year.

At age forty-seven, I thought I found my true lasting love. But I had to accept that, at least at that moment in time, he wasn't. But in that moment, he was a significant part of my journey with love. Sam opened my heart. He also helped me in my journey to get closer to God by sharing his own faith and spiritual practices with me. My relationship with him taught me that I could love another human being, in addition to my child, unconditionally.

But this relationship also taught me where the holes inside myself remained. I still had holes to fill, holes that I'd buried deeply. And loving Sam revealed them.

After our break-up, I accepted the fact that I had a lot more work to do on myself. I wasn't yet close to where I wanted to be as a healthy, loving partner, or where God would want me to be. My issues had backed up against Sam's issues; he and I decided that we each had more personal soul-searching to do.

I was frustrated with myself because by this time, I thought I'd completed the hard work of making myself a whole, emotionally healthy person. Boy, what a punch in the gut this was. All I had done was shove the sad, broken parts of me under the rug. I acted like I was all good and moved on with my life.

I had to come to grips with the fact that I still needed to work on loving myself and healing my past. I've learned that we accept the love we think we deserve. Evidently, I didn't think I deserved anything better than mediocre. So I pushed away anyone and anything that had the potential to be exceptional. But now, I was determined to do whatever it took to change that pattern. I wanted to be in the best place I could be for someone who was worthy of the love I had to give. And I needed to be worthy for that someone as well.

So I set out to finish what I started and dove back into therapy. I did the hard stuff. The work brought up the fact that I had not truly forgiven my family, nor had I forgiven my son's father from a pure, holistic place. Although I had already gone through the exercise of forgiving people for perceived wrongs, my efforts had been superficial, and I hadn't experienced the healing power of true forgiveness. All I did was put a Band-Aid on my deep pain. So in my work, I began the journey of forgiveness in the way that true forgiveness demands.

In order to love myself, I had to first forgive myself. This is an absolute prerequisite to forgiving others. I came to realize that forgiveness involves surrender. I needed to let go of my guilt and shame; I could no longer let myself be hurt or

offended by others' words and actions. And I could only do that by handing everything over to God.

The journey to begin repairing and restoring my broken relationships started with my son's father. I wish I was equipped to begin this process many years earlier, for the sake of my son, but I didn't have the necessary tools. And that is something for which I still need to forgive myself. Healing is not an overnight process. Unfortunately, some people go their whole lives without ever truly healing from their emotional wounds. I did not want to be one of them.

My journey to being whole has been difficult and painful. In order to face myself, I had to face who I am inside. I realized that my own heart needed repair—there was still a defensive wall surrounding it. I had a blind spot that prevented me from seeing the holes inside of me. And the only way I could see them was when my heart opened up.

My heart had been closed off for many years. Dangerously, I believed that I was healed. I am thankful that my time with Sam opened my heart to see the ugly, unhealthy parts that needed to be healed. How could I love anyone else until I felt whole myself?

I desperately wanted to be loved and to be filled with love. If I am accepting of God's love, and my cup is constantly filled with self-love, then I am able to give love to others. And that is what I set out to do. Being consumed with love brings a sense of peace, and as soon as I received my first taste of that lovely calmness, I wanted more. And I continually strive to be at the place where no one can offend or hurt me. I'm happy to say that each day it gets a little easier. The key is accepting

who God made you to be and forgiving yourself for whatever transgressions in the past you continue to hold onto.

"Self-care" seems to be a buzz phrase these days, and it is indeed critical that you take care of yourself first. Once you begin valuing yourself, you will discover that you deserve better than what you may have put up with in your past—from yourself and others.

Reflection

- Have you ever struggled with loving yourself? At some point in time, we all struggle with that, because we are human.

- Do you believe that you are good enough and more than enough? It is imperative that you accept all of who you are in order to thrive in your life.

- Are there parts of you that you need to work on, and have you started?

- Blocking love from others is the most self-destructive thing we can do to ourselves. Can you identify areas in your life where you have a hard time allowing others to give to you?

- How can you go out and be light and love every single day? Can you make it a habit so that it becomes a natural part of your being?

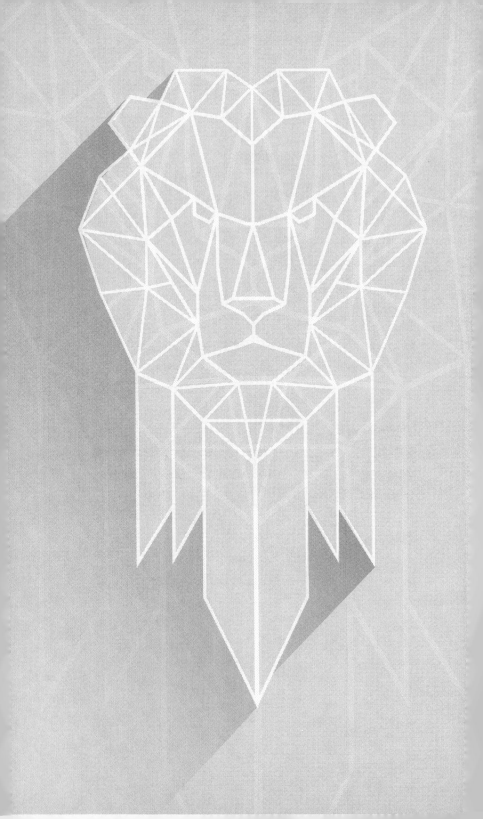

REJECTING DOGMA AND FINDING GOD

"I felt a void that no amount of success and external happiness could fill. I always had a yearning to be closer to God."

The idea of religion has been at the forefront of most wars and has been an enigma for humanity since our existence. If one even believes in God, how does one know what is true and what isn't? For me, I know God has been with me my whole life—always picking me up, always providing for me, always healing me. Even if I didn't know He was there, God has never left my side.

Growing up in a devout Hindu family gave me the foundation to believe in God. But it also gave me a very different perspective of religion that broadened my outlook and made me open to other forms of worship.

I had always been averse to organized religion. I didn't like the man-made structure. I felt more comfortable telling people I was spiritual and believed in God, rather than say that I was Hindu. My mom was eighteen years old when she came halfway around the globe with a strange man she barely knew to a country she didn't know. In many ways, she was still a child, yet she had to grow up quickly. She grasped onto the one thing that gave her comfort: her handed-down version of Hinduism.

My mom held on to her faith tightly. She never veered from the daily prayer rituals of practicing her faith. It was our mom who instilled these religious traditions within our family. My mom curated a beautiful prayer area or room in all the homes we lived in. There, she would put her statues of each avatar of Hindu gods on the table, like Krishna (god of compassion and love), Laxmi (goddess of wealth), Ganesh (god of protection), Shiva (god of fertility), and Sarasvati (goddess of wisdom).

We grew up with her praying every day, twice a day. Her prayer consisted of chants and mantras each morning before breakfast and every night before dinner. In her seventy plus years of life, she has never veered from these practices. No matter where we were in the world, she would accommodate her prayer rituals. We could be on vacation, and she would find a quiet space and time in our hotel room to pray. We would be on a plane, and she would shut her eyes and pray internally. She had the same mantras and prayers memorized so deeply that they just flowed out of her. My siblings and I developed a respect for her devotion,

and we grew our faith based on praying with our mom for every special occasion.

At the end of each prayer time, we would do aarti, a ritual in which a lighted lamp is circled in the air around the prayer table, and my mom would place prasad on our foreheads. Prasad is a paste made from holy powder that signified purification after each prayer time. My mom faithfully practiced all the traditions that were handed down to her.

Hinduism is best described as a mythological religion, that is rooted in the ancient language of Sanskrit. The main text of Hinduism is the holy book known as the Bhagavad Gita. For me, the text was difficult to read as it is not organized or easily deciphered into English translation, nor was the book used much in my experiences during prayer. I remember watching the folklore of the Bhagavad Gita in movie form as a kid. I was fascinated because these movies were action-packed and all about good fighting evil. In fact, my brother and I would collect religious Marvel-like comic books when in India for our summer vacations. These comic books depicted each of the gods and how they came to be in a type of folklore narrative.

In these narratives, the history of how Hinduism originated seemed very dramatic and full of action. My favorite incarnation of God in Hinduism was Ganesh. Ganesh is the elephant-headed remover of obstacles. We would see these god and goddess statues and pictures in every home in India, in the shops, the rickshaws, and pretty much anywhere we went. Hindus are very open in the

display of their religion. As children, we loved visiting the temples in India. There was one on every corner—many built out of stone, all very ancient.

Most of the statues were larger than life, ornately decorated with silks and adorned with jewels. It made me feel the presence of holiness, and it created a sense of peace that we were being watched over. Sometimes, we would take special trips to holy temples deep in the jungle or out in the middle of nowhere. These excursions were wonderful as each place felt authentic and spiritually pure.

There was genuine spirit in India that could never be captured back in the States. No matter how many temples I have visited here, my experiences have never compared to those I had in India. I never felt connected to a temple here. In fact, there are very few temples, so most prayer is practiced in the home. This creates a more isolated way to worship. I have always craved a sense of community and a spiritual support system. We did not have that here. It was nonexistent in Tennessee, with only a few Indian families in our small town of Greeneville.

When we moved to Raleigh, a much bigger city, during my early teen years, we found a larger community and a temple. However, the Indian community was self-segregated by language, and groups within the temple were cliquey. And at some point, the temple became a social spot where parents came to brag about their kids being doctors or getting a perfect score on the SAT.

My siblings and I took part in teenage fellowship at the temple, but the teachings were traditional and not well

translated to speak to our generation. Though the temple housed similar, beautifully adorned statues of our gods and goddesses, their authenticity seemed to be lost. Being Hindu still felt foreign to me.

I rebelled against Hinduism when I became a teenager. I remember one incident that happened during my junior year in high school. I'd just returned from a trip to Paris with my French Club, where I'd bought a cool shorts and blazer outfit that I was dying to wear. We went to the temple as a family. My mom had specifically told me to not wear shorts because not covering your legs or arms is disrespectful at temple. However, I showed up in that outfit.

Looking back at my behavior, I'm horrified—I was a jerk for doing that. I embarrassed and hurt my mother. But it allows me to see now that I was rebelling against a religion that I did not feel connected to and that was being forced upon me. And the real struggle was not with my mom or even Hinduism; it was with the fact that I couldn't grasp the major concepts of the religion and its views about life and death. I had a hard time dealing with the idea of reincarnation and the belief that your deeds would determine whether your next life was going to be great or not. I couldn't accept the concept that my current life was a result of my karmic past life and that I could not change its course no matter what I did. And what about my next life? If I made too many mistakes in this one, would I come back as a cockroach? And if I never managed to "do good" enough in all my lives, would I never reach liberation, where my soul would be with God?

These were the thoughts that disturbed me. And the fact that I was questioning my family's religion added to the guilt and shame that sometimes comes with the Indian culture. My mom was handed down her learning of Hinduism, and she was taught not to question but to do.

I question everything—it comes naturally to me and is part of my personality. Over time, I annoyed my mom by questioning why Hindus did things the way we did or what the prayers meant or how to translate the Sanskrit into English. For her, religion was her entire world and the only thing she had to cling to when she came to a foreign country at age eighteen. She left her family and a country with a greater than 85 percent Hindu population to live in a country with, at that time, maybe a 5 percent Hindu population. It had to be tremendously scary for her. And I can understand why she grasped onto her religion so tightly. It was all she knew.

Hinduism is woven tightly into the fabric of the Indian culture, even here in the States, so separating from it is very difficult. And there are many ways to practice the religion. Growing up, I would learn a Hindu practice one way and find that there was a whole other version of that practice. At the same time, I was also learning about Christianity. But I wasn't a white Christian, and I wasn't a brown Hindu. I was somewhere in between.

One thing about Christianity I did love, however, was the fact that it included every race and culture, whereas Hinduism was predominantly Indian. I was always envious of my Christian friends. They had a large support system—a

life group or prayer group, a pastor they could talk to, a place they could go and worship consistently. I had fond memories of going to summer Vacation Bible School as a child back in Tennessee. It was a fun experience for me, and I understood what was being taught about Jesus's love for all of us. I remember how peaceful and comforting it felt to be in the sanctuary. And I remember going down the steps to the basement level where we assembled in our classroom to learn stories from the Bible and make crafts. Each summer, when the program wrapped up and we left the dining hall after having a delicious snack, I was always sad. I felt community there.

I owe it to my parents for allowing us to experience church as it was completely out of their comfort zone. They were open-minded about us acclimating to various aspects of life in America, but there were limits when it came to religion. I remember that during our early years in Tennessee, my twin brother came home from school one day claiming he was Christian. This was thanks to the encouragement of a neighborhood friend whose parents were devout Christians. I will never forget my dad dragging my brother into our prayer room and making him repent. My father gave him a severe scolding, which put fear in us to never veer outside our religion.

In India, you are born into the Hindu religion, which is closely tied to the caste system. My family came from the highest caste, Goud Saraswat Brahmin (GSB), known as the royals or priest caste. To be born into this caste was a privilege and a birthright, so to not follow the sanctions

of Hinduism was considered sinful. One cannot simply convert or claim they are Hindu. It is a birthright.

Although I have felt blessed and fortunate to have been born a GSB, the concept of the caste system never settled well inside me, especially because Hinduism teaches you to treat all living beings with respect. I always wondered why there was a caste system. The lowest caste was called the "untouchables" and was comprised of the impoverished people in villages or uneducated servants working in homes. My relatives employed servants from this caste. It wasn't that they were treated badly; in fact, house servants were often treated as a part of the family. However, there was still a delineation between us. Untouchables were, on some level, considered to be less human.

I have a childhood memory of visiting my family in India that haunts me to this day. My siblings and I were walking in the street with my cousins, each of us carrying several paises (the equivalent of pennies) in our pockets. We were well dressed and looked like we came from money, so several untouchable children approached us. My brother and I wanted to engage with them and give them some paises, but my cousins told us to not to look at them, not to speak to them, and definitely not to give them money, or they would swarm us. It was so painful for me to witness these poverty-stricken kids, but it was completely normal to them. It's an experience I will never forget.

There was a deep struggle within me about the aspects of Hinduism that I just couldn't get on board with. At the same time, I don't want to suggest any disrespect for my

family, ancestors, or Hinduism since much of who I am comes from the religious practices and beliefs by which my parents raised me.

Once I became an adult, I found myself constantly drawn to the beautiful scriptures in the Bible. Yet I also experienced the hypocrisy of false Christians in my life. One Southern Baptist Christian had called me the "devil's seed," and another one told me that he couldn't date me because his family would never accept me or my Hindu family. In essence, I was turned off by religion.

So although I always believed in God, I could not see myself fitting into any religious group. And I was troubled by that. I lived a good life, but that wasn't enough. I felt a void that no amount of success and external happiness could fill. I always had a yearning to be closer to God. I just didn't know how to do that. In this country, there aren't resources for Hindus the way there are for Christians. I had no idea if my prayer had any meaning.

In 2004, I went to the movie theater to see Mel Gibson's controversial movie *The Passion of Christ*, which depicted Jesus's final days. I was so deeply moved by the movie that, fifteen years later, I still vividly remember the gruesome scenes of the punishment Jesus endured. I cried throughout most of the movie, shaken by this graphic Biblical account of Jesus's life.

I noticed that God kept putting faithful, nonjudgmental, unconditionally loving Christians in my life. Pretty soon, my longest-term client, my best friends, and my then boyfriend, Sam, were sharing their faith with me. All of them had

the same core operating system, and they all had strong values and faith in prayer. Whenever I was going through a difficult time, my wonderful Christian friends asked if they could pray over me and with me. I was yearning to have that kind of conviction for myself. Somehow my prayers always felt different than theirs did.

They each invited me to go to church with them a number of times, but I would mostly answer no. I resisted partly because of the hypocrisy I'd experienced by other people claiming to be Christians. But more than that, I was afraid of turning my back on my culture, my identity, and my family.

For a long time, I felt stuck. I was just going through the motions in my life, floating along without a real sense of direction. When I had my emotional breakdown, I knew that I needed God in order to get back to healing. I saw how He was working inside of me, calling me to Him, but I didn't know how to respond or what my life's purpose was. This had slowly been killing me on the inside. I needed to figure out how to get closer to God. I just didn't know how or where to start.

The first time I went to church as an adult for worship was eight years ago, when I was let go from my job and was starting my new entrepreneurial venture. I was lost. My very first client and now brother, Stratos, invited me to attend his church. I found it be a powerful experience. God was talking to me and telling me that all would OK. I went back to his church one other time but then decided that because I wasn't Christian, it didn't make sense for me to continue.

I had always yearned for the community that Christianity offered. When my son's father and I divorced in 2005, I decided to hire a coach to help me get my "mental footing" back. That coach was Leonard Wheeler. I was drawn to Leonard for his integrity and love for God, even though his religion was different from mine. Leonard is very outward about his Christian faith, and he always began and ended our coaching sessions with prayer. Though this practice felt a bit uncomfortable because it was foreign to me, I welcomed it because I figured that any and all prayer would help me get through this stressful and emotional period. And there was something about Leonard. His calm self-assuredness was something I continued to see in other strong Christians that I would meet down the road.

I attended church again in April 2018 with Sam, my then boyfriend. On one of our early dates, we talked about his deep faith in Jesus and the fact that he wanted to marry a Christian woman. I remember that conversation well because I told him that I was never going to be that woman. I was never going to change who I was because I loved who I was. And I especially was not going to change my religion for anyone else.

However, I loved Sam. I wanted to be a part of his life and grow from our shared experiences, so I agreed to go to church with him. I remember walking into Forest Hill Church, a well-known nondenominational church in Charlotte, feeling out of place and uncomfortable. We walked into the huge sanctuary—just the size alone of this church was intimidating—and Sam selected a pew

in the middle that allowed me to feel more comfortable and obscure.

The service began with a band playing several upbeat worship songs, and the congregation sang along, clapping, waving arms, and being in joy. I stood there, taking it all in. After the worship music ended, the room went dark. A video popped up on a big screen. And what happened next is something I will never forget. On the screen was a young Indian girl speaking. She had to be around twelve years old. My body froze, and I sat there in shock. I looked over at Sam, and he just shrugged. He leaned over and whispered to me that he had never seen this video before. As we watched, the girl in the video told an emotional story about how Jesus had saved her family and her father. Her father had been angry and abusive, but the love of Jesus transformed all their lives. The girl's testimony had been recorded as part of the Forest Hill Church's ministry in India.

I broke into tears and couldn't stop weeping. I was speechless for the remainder of the service, and I don't remember a thing that happened after that video. I was quiet in the car after the service, and I had no energy to go to brunch, so Sam drove me straight home.

I couldn't believe how emotionally drained I was. I got into my pajamas and crawled into bed. I had no idea why I felt zapped, almost crippled inside, as if a tug-of-war was going on deep in my spirit. I remained in bed the rest of the evening, sobbing on and off.

When Sam invited me to church again, I was scared to go back. In fact, I did not go back again for several weeks.

Finally, I decided to return because I was curious about why I had such an emotional response. So Sam took me to Forest Hill again, and once again, I cried during the worship music. The words of the songs were speaking to me about being a child of God and how grace and forgiveness were ours. I soaked up the message and the entire experience of being in a church full of worshippers. And once again, I went home drained and exhausted. And so it was the next time I went and the time after that.

I felt badly for Sam since I ended up being an absolute mess whenever I went to church with him. On one Sunday, I sobbed so loudly during the final worship song that he had to hold me tight and sing louder to drown out my sobs. It was clear that there was something stirring inside of me. It was a weird mix of intense joy and pain. Why was it that church created such tormenting emotions inside me?

It took me awhile to understand what in the world was going on. I finally figured out that I was feeling a deep-rooted guilt for secretly loving the Bible and wanting to learn more about Christianity. This went against everything I knew about religion up until that point in my life. I believed that me becoming a Christian was "wrong" because it meant turning my back on my family, my culture, and my roots. It was this inner conflict that made me so emotional. I desperately wanted to feel the love and the forgiveness that I'd found in Christianity but had never experienced in Hinduism. And I was in love with the fact that anyone can simply declare that they want Jesus in their heart and start life as a new spirit.

One of the people I reached out to as I was going through this internal struggle was Cyril Prabhu, the founder of a nonprofit organization near Charlotte called Proverbs 22:6. Cyril is an Indian Christian from Tamil Nadu, India, who is married to a Hindu. This man is dedicated to the service of God and is a pillar of the community. Cyril helped me take the step of letting go of my guilt. He kept checking up on me throughout my journey and continued to be an admired mentor as I began my new life as a Christian.

When I told my Christian friends that I wanted to start this journey, one of my dearest friends, Rebecca, gifted me a Bible. I was eager to learn the way Jesus lived and taught us to live. Over the course of several months, Cheale, another one of my besties, and I had long talks about Christianity. She became one of my mentors in learning how to love and live with grace, patience, and forgiveness.

Once I decided to be a Christian, I had to think long and hard about how I should tell everyone. And I mean everyone. I wanted to do it all at once so that I never had to repeat myself. Plus, making the news public meant I could not turn back. I decided that Facebook would be the best way to do this. So I crafted a lengthy declaration that announced to my Hindu family and friends that I was converting to Christianity. I assured everyone that no one was making me do this and then invited anyone who wanted to unfriend me to go ahead and do so. I posted this to Facebook a few days before Thanksgiving 2018.

To my surprise, no one unfriended me (that I know of anyway) or made disparaging remarks. Instead, I received an

overwhelming number of comments from people who fully supported me. The most surprising response was an inbox message from one of my Indian friends of over twenty years. She informed me that she and her siblings had converted twenty years ago and that her parents accepted their new religion. What? I never knew! She and her siblings had kept it private all those years—and for good reason. It was out of the very real fear of being ostracized or judged by Indian friends and family.

Forgiveness, grace, and love became more apparent in my life as I moved forward. I experienced them in ways I never had before. I started to feel my heart changing. And for a gal who didn't like the idea of organized religion, I was surprised to find myself hungering to go to church every Sunday. My life was transforming. I felt lighter and more peaceful, no matter what storm I was in. And at that time, I was going through a large one.

I had heard friends talk about spiritual warfare, but I had no idea what they meant—that is, until I made my public declaration of becoming a Christian. Once I took that step, I felt that the devil was attacking me at every turn, wreaking havoc with my mind and in my relationships. My relationships with my family and my then boyfriend, Sam, were on the rocks because of all of the storms I was going through in my life. I felt that my storms were tearing me apart from the ones closest to me.

I was scared to death to tell my parents about my decision to leave Hinduism, and in one text conversation with my mother, she stated she felt I was joining a cult.

I could not blame her one bit. The Christianity she witnessed in her lifetime was far from the love, grace, and forgiveness I had experienced. My father never really expressed an opinion verbally, but I am fairly certain he was not happy about it, given the fact that many years ago he was highly upset at my brother for coming home claiming he was Christian. In the finishing stages of writing this book, my mother told me that she and my dad just wanted me to be happy, and if this brought me happiness, then they were at peace. She was happy that I believed in God.

On the flip side, I gained a strength I'd never known before. I began praying more consistently and talking to God. I felt God's presence beside me and inside of me, working on my spirit. I sensed that my life had been changed, but more importantly, it had been saved. I finally felt less fear and more faith.

Those last parts of my brokenness, the holes in my heart that never fully went away, began to heal. And I became better equipped to cope with daily struggles, fight life's challenges head-on, and accept those situations that I couldn't change. Every time I wanted to turn back around into my darkness, God kept giving me signs, telling me He was with me and to keep the faith.

If I look at the pivotal moments in my life, God has been right there with me. He allowed me to make my own way. The path was not easy, and I fought every step of the way to achieve my dreams. Every time someone said that I couldn't, I made sure that I did. Every time I didn't have

the vision, God planted it in my heart and mind and gave me the tools to bring it to fruition.

When I started my journey of following Jesus and accepting Him in my heart, I wanted to learn all that I could. I visited different churches, watched many pastors' messages online, read books about faith, listened to worship music, and talked to every person whose walk in the Christian faith I respected.

I was referred to an amazing executive leadership coach named Dr. Roshon Bradley, who holds a doctorate in executive leadership education. It seemed like Dr. Bradley came into my life divinely. As a newbie in the Christian faith, I needed a strong moral, ethical, God-loving person to help guide me on my journey. In my three short months with Dr. Bradley, I was hungry to learn all that he had to offer me as a spiritual leadership coach. In fact, he told me that he'd never had a student soak up so much new knowledge so quickly. I believe that I "got it" because my desire to heal and grow spiritually enabled me to surrender and have my heart transformed.

About this time, I also began to pray for God to bring someone into my life who could understand the path I was on—not just a similar path but the exact same path. In sacrificing everything, including my family's beliefs, I needed to know that there was someone out there who could fully understand me—someone who could help me feel less alone on my journey. I prayed for months for this special person.

Growing up in Tennessee and North Carolina, I knew every Konkani-speaking (my mother tongue) GSB Brahmin

(my caste) from Mangalore, India, (my parents' small hometown) in a four-state radius, especially in my age group. My caste is known as the highest. This is the priesthood caste, and it is our birthright to be Hindu. There are only 340,000 of us in the world.

About seven months into my new faith journey, I commented on a friend's Facebook post. Another friend of this friend, named Shalini, saw my comment and recognized my last name as being Konkani. She asked our mutual friend about me on the same post. Of course, Shalini and I quickly connected online to learn more about one another. Unbelievably, like me, Shalini lives in Charlotte and has exactly the same roots I do. In fact, we could be related. And she started following Jesus twenty-five years ago! I never knew she existed—and in my own back yard no less—because being a Christian, she was never spoken of in the Konkani circles here in the States. What were the chances of the two of us finding each other? Shalini is now a sister. God answered my prayers.

At this point in my journey, I know for certain that following the path I'm now on was the only way for my heart to transform and my spirit to heal. Nothing had worked before. I tried therapy, self-help books, and a wide variety of the programs and self-improvement tools that are out there, but without God in my life, they provided only a temporary fix. Healing was never complete.

I see the world differently now. I started *being* love and pouring love out because I have become filled with it. I restored relationships with people whom I never expected

would give me the time of day again. I surrendered. In my walk with Jesus, ego has no place. We fight our egos every day. Now I see that if someone is angry with me or says hurtful things, it isn't about me. These reactions often reflect that person's own insecurities and unfinished healing. I also see that forgiveness is the only way to peace and that love truly does drown out hate.

We're unable to respond to love if all we've received is hate. It is our job to pour love out, without expecting anything in return. That was the part I was missing.

I do not believe God put us on this Earth to merely exist and be mediocre. I believe that He put each of us on this Earth to figure out our unique purpose and execute it to the fullest. I believe that we are here to impact the world for the better, each of us in our own way. Whatever religion you practice or whatever beliefs you hold, that it is only for you. You cannot let the other voices tell you how to believe or feel. No matter what faith tradition you were raised in, do not let the dogma of religion you grew up with stop you from living freely in your beliefs.

Reflection

- How important is it to you to trust in a higher power in your life?

- Do you judge others for what they believe?

- How has your spiritual or religious upbringing shaped your beliefs and your life journey, whether positively or negatively?

- Do you feel that you have to believe in something because that is what was handed down to you from generations before?

- Do you feel that religion is a very personal choice? Unfortunately, many of our world wars are because of religion. But we can start with ourselves.

ABOUT THE AUTHOR

Nesha Pai is the founder of Pai CPA, LLC, in Charlotte, North Carolina. Her hometown is Raleigh, North Carolina. She graduated magna cum laude from North Carolina State University in Raleigh and has held her CPA license since 1996. She began her career within the world-renowned accounting firm Arthur Andersen and worked later within multiple, privately held Fortune 500 companies as a business consultant, relationship facilitator, and accounting analyst. Then she realized she had a passion for the small business and entrepreneurial sector.

Since starting her own firm in 2011, Nesha has continued nourishing her own passion and the business growth of Charlotte by creating Pai Networking Group in 2017 and launching a podcast series, *Piece of the Pai*, that focuses on allowing successful entrepreneurs to share their business insight. Nesha has been a Charlotte resident since 1993. Apart from her passion for entrepreneurs, she enjoys fitness, art, traveling, food, and being fashion forward.

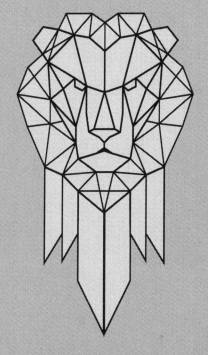

Visit NeshaPai.com
to join the community
and invite Nesha to speak
to your organization.

Made in the USA
Lexington, KY
07 December 2019